IMAGES of America
AFRICAN AMERICANS OF FAUQUIER COUNTY

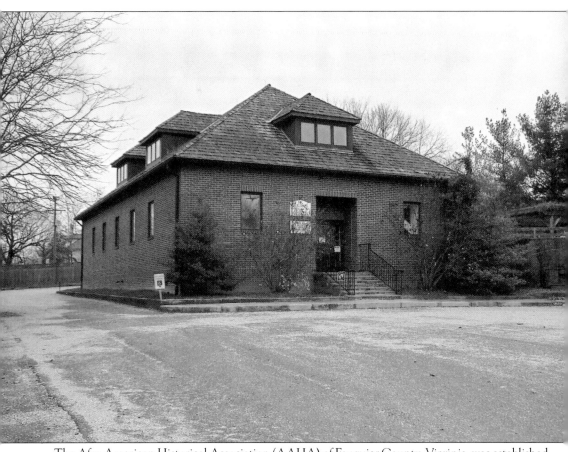

The Afro-American Historical Association (AAHA) of Fauquier County, Virginia, was established in 1997. It is located at 4243 Loudoun Avenue in The Plains, Virginia. All photographs and other images in this book are housed at AAHA. The archives contain thousands of documents and oral histories for use by genealogical and historical researchers.

ON THE COVER: A 1967 kindergarten class is photographed at Green's Private School in Madisontown, Warrenton, Virginia. Lena T. Green was the teacher and founder.

IMAGES of America
AFRICAN AMERICANS OF FAUQUIER COUNTY

Donna Tyler Hollie, Ph.D.,
Brett M. Tyler, and Karen Hughes White

Copyright © 2009 by Donna Tyler Hollie, Ph.D., Brett M. Tyler, and Karen Hughes White
ISBN 978-0-7385-6757-0

Published by Arcadia Publishing
Charleston, South Carolina

Printed in the United States of America

Library of Congress Control Number: 2008943897

For all general information contact Arcadia Publishing at:
Telephone 843-853-2070
Fax 843-853-0044
E-mail sales@arcadiapublishing.com
For customer service and orders:
Toll-Free 1-888-313-2665

Visit us on the Internet at www.arcadiapublishing.com

To our parents, who taught us to love learning.

Contents

Acknowledgments		6
Introduction		7
1.	Trails to Freedom	9
2.	Standing on the Solid Rock	33
3.	Let There Be Light	55
4.	From Fields to Front Lines	81
5.	Ties That Bind	105

ACKNOWLEDGMENTS

As we send this book to press, we want to extend deepest gratitude to the African American community of Fauquier County as well as the individuals and organizations who have nurtured and supported the Afro-American Historical Association of Fauquier County since 1992.

We are indebted to you: for the inspiration, time, donations, and most of all the moral support that brought us from an idea to a thriving community resource. The photographs and facts in this book are a tribute to the strength and resilience of the ancestors and descendants. These faces and stories come from you and are dedicated to you.

Special thanks to the AAHA staff and volunteers for their dedication and hard work collecting and preserving the legacy of this community. We gratefully acknowledge Jane Butler, Sherrie Carter, Sheila Campbell, Norma Logan, Ebonee Sanders, and Kristina Slaughter for the countless hours and dedication given to this project. We are appreciative to Washington Green Jr. and Laura Lyster-Mensh for their invaluable assistance.

Thanks to our families for the hours missed, your love, concern, and support!

Thanks to the board members, Angela Davidson, Karen K. Lavore, Miriam Porter, and Lisa Tines, for your longtime support and guidance to AAHA.

To The Plains Redevelopment Corporation, the Wrinkle In Time Foundation for their continued sponsorship of AAHA, and those responsible for the day-to-day maintenance of 4243 Loudoun Avenue, we are humbled. To the quilters and cast, your commitment to sustaining AAHA is graciously acknowledged.

Thanks to the descendants of Fauquier County's African American community for your willingness to share and eagerness to preserve the legacy of your ancestors for the benefit of future generations.

And finally, thanks to the ancestors. You worked the soil, constructed the roads and buildings, and played a major part in the history of this region. You withstood hardship and raised families and neighborhoods. You thrived and sent proud citizens out into society and sustained a presence in Fauquier, the Piedmont area of Virginia, the nation, and the world. We honor you and thank you for a proud heritage we seek to carry on to our own generations. All images are courtesy of the AAHA.

Introduction

Sticks in a bundle are unbreakable.

—A proverb from Kenya, East Africa

Without a doubt, enslaved and free African Americans in Fauquier County, Virginia, understood this African proverb and united to sustain themselves through bondage, Reconstruction, and the challenges of this modern age. Bound together by culture, skin color, and an indelible desire to make the best of their condition, our ancestors formed enduring families, communities, and institutions.

Fauquier was, and remains, predominantly rural, and slave labor was an absolute necessity for the farming and, to a lesser extent, the mining that formed the basis of the county's economy. The earliest known references to African Americans in Fauquier are found in 1761, when county records reveal that Fauquier residents were hiring slaves skilled in blacksmithing, masonry, spinning, and weaving. These skills, combined with those required to produce labor-intensive crops such as corn, wheat, oats, and tobacco, caused the African American populace to grow steadily, even surpassing the white population during the 1850s.

Inheritors of strong, resilient minds and bodies, they obviously retained many precolonial West African values—an unending quest for God, love of family, respect for elders and the rule of law, and an honored tradition of collective efforts for the community's gain—that accompanied them on the tortuous journey to America. Those values continue to this day.

Slavery, no matter how liberal, is cruel. However, life for antebellum African Americans in Fauquier was not as brutal as for their kin in America's Deep South. Most county slaveholders owned small farms with relatively few slaves. Frequent and intimate interactions between the races were the norm in this setting, and mutually beneficial relations between the races were formed and have lasted for generations. Additionally, Virginia's and Fauquier County's unusually liberal support of religious instruction for all youth may well have had the unintended effect of fueling a desire for learning and equality among the very people for whom education was specifically outlawed. The fluency and excellent penmanship of early postwar church records as well as business and personal letters leave little doubt that a significant portion of the African American population had become literate well before emancipation.

The images in this book are about the "bundle" of black folks who formed and supported the families, churches, schools, lodges, benevolent societies, and businesses that define who we are. The earliest African American institutions in Fauquier, after families, were the churches. There were at least 10 African American Baptist churches in the county by 1870 and 19 by 1891. Many of these are still in existence and have their origins in worship services held in slave cabins and "bush arbors," outdoor spaces with tree branches overhead as shelter from the elements, during slavery. The roots of most of the county's primary schools can be traced to these congregations.

Together the families, churches, schools, fraternal groups, and civic organizations created the rich and colorful tapestry that you are about to enjoy. Armed with a powerful inheritance and an ability to recognize and seize opportunity whenever possible, Fauquier's African Americans have made the county a better place for all of its citizens.

A single bracelet does not jingle.

—A proverb from the Congo, West Africa

One

TRAILS TO FREEDOM

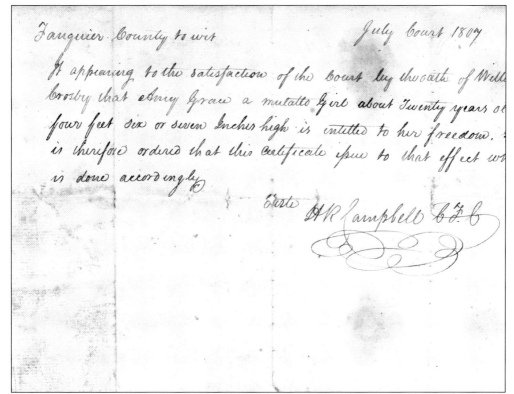

African Americans followed many trails to freedom. Some were born free. Others earned money to purchase themselves and their relatives. Some were emancipated by owners who found slavery immoral or unprofitable. The more daring emancipated themselves by running away. Most remained enslaved until January 1, 1863, when the Emancipation Proclamation became effective. Amy Grace's free status was recorded in the Fauquier County courthouse in 1807.

Because of the many laws governing free people of color, historian Ira Berlin refers to them as slaves without masters. These documents illustrate a few of the many laws that impacted free black people. In 1786, white citizens certified that James Nickens, a man of good character, was free and with his wife and children had resided in Lancaster County. The 1801 freemen's pass permitted Nickens and his son, James, to travel from Fauquier to Alexandria with two of his grandchildren, Elizabeth and John Watkins. The April 25, 1806, document attests to the fact that Sarah Nickens was born free to a free woman in Northumberland County. In 1793, William McClanahan, to whom Peggy Bender (also known as Timbers) was indentured, gave his consent for her to marry James Nickens, a free man.

Spencer Hall was born about 1811. Hall testified before the Southern Claims Commission, a federal agency that provided financial compensation to Union loyalists who suffered financial losses during the Civil War, that he was freeborn. According to the Prince William County census of 1850, he was free. Elizabeth (Betsy) Thomas, a free black woman born in 1828, advertised for a helper. Hall, a blacksmith, answered the advertisement and subsequently married Thomas. They were the parents of eight children whom they raised in Fauquier's Hopewell community. By 1870, the Halls had accumulated $1,000 in real estate and $500 in personal property. Their descendants were members of First Baptist Church in The Plains and Oakrum Baptist Church in Thoroughfare. A newspaper advertisement for a runaway slave suggests that Spencer Hall may have helped slaves to escape via the Underground Railroad.

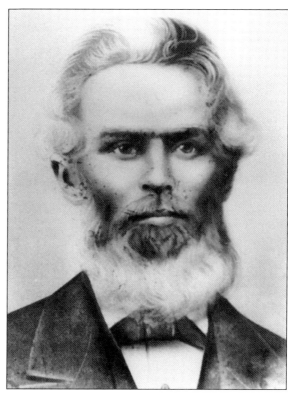

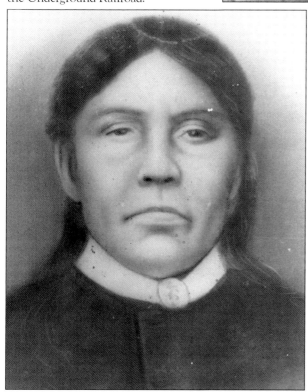

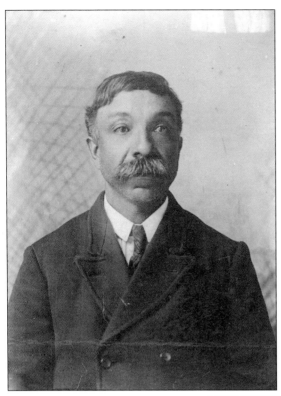

Eli Addison Blackwell was born in September 1857. In 1859, he was one of the 87 slaves emancipated by the will of Elizabeth Blackwell. Blackwell willed her property to the adult slaves, including Eli's mother, Millie. Eli and his wife raised 10 children in the community known as Blackwelltown, and their descendants continue to live on the property inherited from Elizabeth Blackwell. Eli was a farmer and a deacon at Ebenezer Baptist Church for 34 years. He died in 1938. Emily Mauzy Blackwell was born in 1857 and died in 1944. She was a daughter of John and Agnes Saunders Mauzy and married Eli Addison Blackwell in 1879. She lived her entire life in the Midland and Blackwelltown communities.

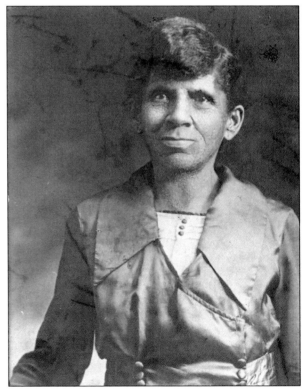

Virginia:

Number 18.

In pursuance of an act of the General Assembly of the Commonwealth of Virginia, passed on the 2nd day of March, 1819, entitled, "An Act reducing into one, the several acts concerning Slaves, Free Negroes and Mulattoes, I, JOHN A. W. SMITH, Clerk of the County Court of Fauquier, do hereby certify, that Margaret Hughes, a bright Mulatto woman, with two scars on the left arm above the elbow, occasioned by a kick, her eyes black, aged thirty-six years, five feet two inches high, who was born free, is registered in my Office agreeably to the directions of the above mentioned Act.

Certified under my hand, and the Seal of Fauquier County, this 17th day of June 1820, and in the 45th year of the Commonwealth.

Jno: A. W. Smith, Clerk.

Attest _____ a Justice of the peace of the County of Fauquier.

In 1820, Margaret Hughes was issued a document of great importance by the clerk of the Fauquier County Court. In 1824, Thomas Walker received an identical document. These documents certified that they were not enslaved people, and Hughes and Walker would have guarded them with great care. All African Americans were presumed to be enslaved until proven otherwise, and any white person had the authority to stop them and demand proof of their status. Free blacks in other areas of the country were kidnapped, had their proofs of freedom taken from them and destroyed, and were sold into slavery.

Virginia:

Number 67.

In pursuance of an act of the General Assembly of the Commonwealth of Virginia, passed on the 2nd day of March, 1819, entitled, "An Act reducing into one, the several acts concerning Slaves, Free Negroes and Mulattoes, I, JOHN A. W. SMITH, Clerk of the County Court of Fauquier, do hereby certify, that Thomas Walker, a black man, aged twenty-one years, five feet seven & a half inches high, who was born free, is registered in my Office agreeably to the directions of the above mentioned Act.

Certified under my hand, and the Seal of Fauquier County, this 22d day of March 1824, and in the 48th year of the Commonwealth.

Jno: A. W. Smith, C.C.

Attest _____ a Justice of the peace of the County of Fauquier.

This Indenture MADE THIS 5th day of May in the year of our Lord 1821 and in the 45th year of the independence of the United States of America, between Andrew Chunn and Rawleigh Hickerson overseers of the poor of ___ district, in the county of Fauquier state of Virginia, of the one part, and Henry Turner of said county, of the other part, witnesseth, that the said Andrew Chunn and Rawleigh Hickerson overseers of the poor, as aforesaid, by virtue of an order of the court of the aforesaid county, bearing date the 1st day of February in the year 1821 have put, placed and bound; and by these presents do put, place and bind Enoch Nickins a poor boy of color of the age of six years, to be an apprentice with him the said Henry Turner and as an apprentice with him the said Henry Turner to dwell from the date of these presents, until the said Enoch Nickins shall come to the age of twenty one years, according to the act of the general assembly, in that case made and provided. By and during all which time and term, the said Enoch Nickins shall the said Henry Turner his said master well and faithfully serve, in all such lawful business as the said Enoch Nickins shall be put unto, by his said master, according to the power, wit and ability of him the said Enoch Nickins and honestly and obediently in all things shall behave himself towards his said master, and honestly and orderly towards the rest of the family of the said Henry Turner. And the said Henry Turner for himself, his executors and administrators, doth hereby promise and covenant to and with the said overseers of the poor, and every of them, their and every of their executors and administrators, and their and every of their successors for the time being, and to and with the said Andw. Chunn & R. Hickerson that the said Henry Turner shall the said Enoch Nickins teach in the craft, mystery and occupation of a Tanner & Carier which he the said Henry Turner now useth, after the best manner that he can or may teach, instruct and inform, or cause to be taught, instructed and informed as much as thereunto belongeth, or in anywise appertaineth: And that the said Henry Turner shall also find and allow unto the said apprentice sufficient meat, drink, apparel, washing, lodging, and all other things needful, or meet for an apprentice during the term aforesaid: And also that the said shall teach, or cause to be taught to the said reading, writing, and common arithmetic, including the Rule of Three; and will moreover pay to the said Enoch Nickins the sum of twelve dollars, at the expiration of the said term. In witness whereof the parties to these presents have interchangeably set their hands and seals the day and year above written.

Witness
Mason Foniest,
Nimrod Ashby, for A. Chunn

Andrew Chunn (Seal)
R. Hickerson (Seal)
Henry Turner (Seal)

People with limited financial resources, mothers with children born out of wedlock, and free blacks often became the responsibility of the overseers of the poor. Enoch Turner, a six-year-old free boy, was apprenticed to Henry Turner until the age of 21. Henry was obligated to provide for Enoch all the necessities of life and to teach him a trade with which he could support himself when the indenture period ended. Enoch was obligated to be a good and faithful servant. For many people, African American and white, the indenture system prevented starvation and deprivation. In reality, it was a modified form of slavery, and those who tried to escape were severely punished.

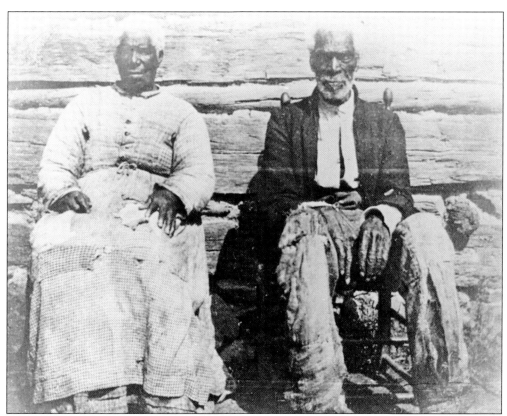

George Tyler was born in 1800 and died in 1903. His wife, Marjorie Chapman, was born in 1808 and died in 1905. Both were slaves of the Boteler/George family. They were the parents of 14 children and saw five of them sold away during slavery. After the war, they were farmers and active members of Ebenezer Baptist Church in Midland. Many of their descendants still reside in Fauquier.

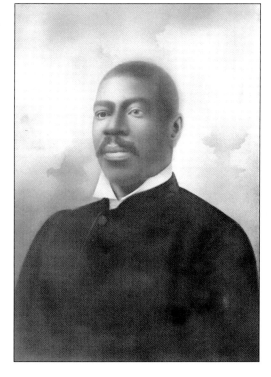

Rev. Chapman Marshall Tyler, a son of George and Marjorie, appears as an eight-year-old slave in the 1853 Division of Assets of Joseph Boteler. Tyler was valued at $350. In freedom, he was a successful farmer, teacher, and minister and one of the most prominent, influential members of the African American community. He served as pastor of Cross Roads, Oak Shade, Hearts' Delight, and Silver Hill Baptist Churches.

MARRIAGE LICENSE.

VIRGINIA— TO WIT:

To any Person Licensed to Celebrate Marriages:

You are hereby authorized to join together in the Holy State of Matrimony, according to the rites and ceremonies of your Church, or religious denomination, and the laws of the Commonwealth of Virginia, Solomon Neverdon and Zacharetta Blackwell

Given under my hand, as Clerk of the County Court of Fauquier this 20th day of December 1865

Wm A Jennings Clerk.

CERTIFICATE TO OBTAIN A MARRIAGE LICENSE,

To be annexed to the License, required by the Act passed 15th March 1861.

Time of Marriage, 25th December 1865
Place of Marriage, Fauquier County Va
Full Names of Parties married, Solomon Neverdon & Zacharetta Blackwell
Age of Husband, Twenty four years
Age of Wife, Eighteen years
Condition of Husband (widowed or single), single
Condition of Wife (widowed or single), single
Place of Husband's Birth, Fauquier County Va
Place of Wife's Birth, " " "
Place of Husband's Residence, " " "
Place of Wife's Residence, " " "
Names of Husband's Parents, Abraham Neverdon & Eliza Neverdon
Names of Wife's Parents, Zachariah Blackwell & Caroline Blackwell
Occupation of Husband, Laborer

Given under my hand this 20th day of December 1865.

Wm A Jennings Clerk.

MINISTER'S RETURN OF MARRIAGE.

I CERTIFY, that on the 25 day of Jan 1865 at Liberty Mines Fauq Co Va I united in Marriage the above named and described parties, under authority of the annexed License.

T W McMurran

☞ The Minister celebrating a Marriage is required, within ten days thereafter, to return the License to the Office of the Clerk who issued the same, with an endorsement thereon of the fact of such Marriage, and of the time and place of celebrating the same.

Before the Civil War, marriages between slaves had no legal standing. In some instances, slaves were forced to marry a partner of the owner's choosing. Some slave owners, reasoning that a slave with family ties was happier, more productive, and less likely to run away, supported their slaves' choices of partners and provided wedding ceremonies. If two slaves of different owners wanted to marry, some owners would agree as to which slave should be sold so that the two could be together. Some male slaves preferred to marry women who lived on neighboring farms/plantations; in this manner they would not have to witness acts of cruelty and abuse that they could not, without fear of physical punishment, prevent or defend. Sadly, slave marriages were sometimes dissolved by the sale of the partners. After emancipation, the first act of many of the freedmen was to reestablish and legalize their relationships. Solomon Neverdon and Zacharetta Blackwell were among the first freedmen to marry in Fauquier County.

Solomon Neverdon was born in 1840, the son of Abraham and Eliza, and died in 1907. His mother was enslaved by the Kemper family. He lived in the Cross Roads community and worked as a blacksmith. His marriage to Zacharetta Blackwell, the daughter of Zachariah and Caroline, produced eight children. Solomon was a member of Silver Hill Baptist Church and was frequently asked to sing at other churches throughout the county.

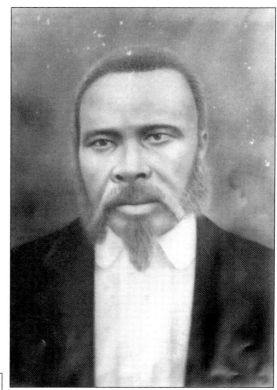

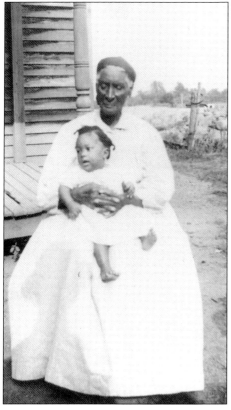

Zacharetta Blackwell Neverdon was born on February 28, 1845, and died on December 4, 1959, in Midland. She was the daughter of Zachariah and Caroline Case Blackwell. In this photograph, she holds a great-granddaughter, Charlotte Brooks. Charlotte was the granddaughter of William and Lucinda Brown Neverdon and the daughter of Edward and Oma Neverdon Brooks.

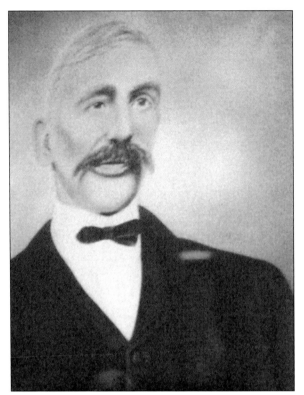

Born in 1854, Gillison Wanser was a slave of Martha Bayliss. In her will, he was listed as a one-year-old valued at $100. He was the son of John and Frances Gaines and the stepson of Robert Wanser, whose surname he adopted. Gillison Wanser, a farmer, purchased 21 acres of land in 1885 from William C. Anderson and his wife, Lucy. In 1898, he was able to purchase an additional 200 acres. Pictured below is his first wife, Mary Newman (1860–1889), a daughter of Sophia Newman. They were married in 1878 and were the parents of six children. They were members of Beulah Baptist Church in Markham.

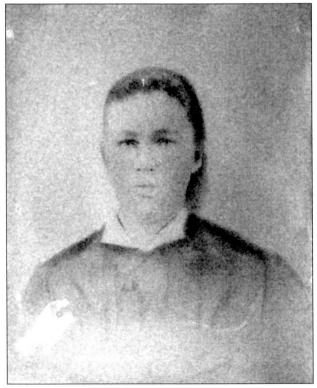

Robert Gaskins (1853–1927), the son of Hezekiah and Fannie Gaskins, was a stone fencer and farmer. He married Eliza Jane Walden, the daughter of Hedgeman and Maria Walden, in 1874. Eliza, a mother of six, died in 1896. Robert's second wife, Annie Ferguson, died childless. Gaskins married Elizabeth Clark in 1901; they had six children. Elizabeth taught at Fenney's Hill School and belonged to Beulah Baptist Church in Markham.

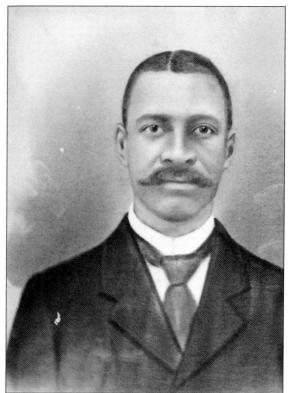

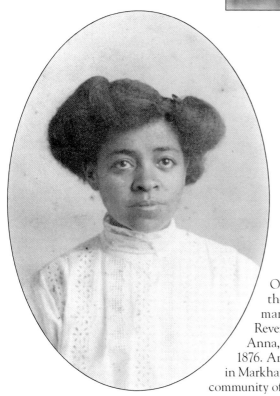

On October 19, 1892, Anna Maria Gaskins, the daughter of Robert and Eliza Gaskins, married the widowed Gillison Wanser. The Reverend G. C. Banister performed the ceremony. Anna, who gave birth to five children, was born in 1876. An active member of Beulah Baptist Church in Markham, she was a highly regarded member of the community of Sage. She died on April 25, 1942.

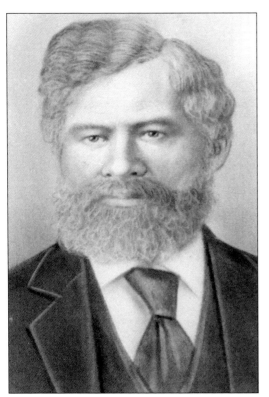

Lyttleton Jackson was born in 1815. He was a farmer who became active in two churches. He was a member of Mount Morris Baptist Church in the community of Hume. On August 2, 1890, elder Cornelius Gaddis and elder Mark Russell of Mount Morris organized Chestnut Hill Baptist Church in Orlean. In this church, Lyttleton Jackson was ordained as a deacon. He was married to Lucy (below), who was born between 1845 and 1850. It is likely that her maiden name was Ferguson. They were the parents of six daughters and six sons. Jackson left 111 acres of land to be divided among his heirs after the death of his wife.

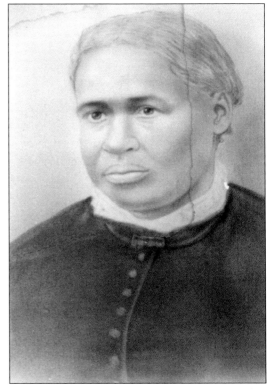

Thomas and Ida Hawkins Jackson were married on January 23, 1889, in Harrisburg, Pennsylvania. Thomas was the son of Hannah Jackson and was born in 1862 in Rappahannock County, Virginia. Ida, a daughter of James and Harriet Sweeney Hawkins, was born on January 18, 1871, in Charlestown, West Virginia. The couple lived in Africa Mountain, a community established on Rattlesnake Mountain around 1850. Many descendants of the original inhabitants live in Africa Mountain today and bear the surnames Baltimore, Combs, Criseman, Ford, and Jackson. The Jacksons were members of Mount Paran Baptist Church. Thomas died on May 10, 1920, and Ida died on April 20, 1948.

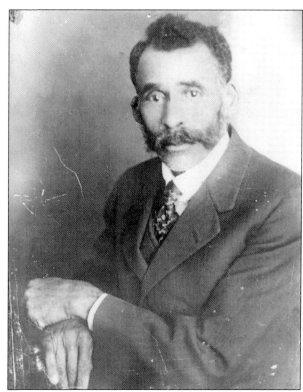

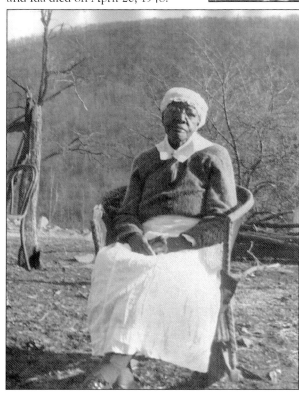

$20 REWARD.

RANAWAY from the subscriber on the 26th day of October, 1834, a negro woman named CLEARY, about 18 years of age. She is supposed to be in the neighborhood of Rectortown, being formerly purchased from a Mr. Rector, near that place. I will give the above reward for the apprehension of Cleary, if detained so that I get her again.

GEORGE NELSON.

Fauquier Co., Jan. 24, 1835—3t

$50 REWARD.

RAN AWAY from the subscriber, living near Warrenton, Fauquier county, Virginia, on the 27th of last month, two negro men, viz.

SAM, about 65 years of age, and 5 feet 8 inches high; a dark complexion; has a wen on the back side of his neck, about the size of a man's hand; has a pleasing countenance when spoken to; and a quick walk when moving.

TOM, is 30 years of age; and is about 5 feet 10 inches high; nearly of the same colour of Sam; has a down look when spoken to; and slow to answer when talking; and is slow in his movements.

The above will be paid if taken and secured in any jail, and information given, so that I get them.—If brought home I will pay all lawful expenses.—If but one is taken, half of the above will be only paid.

PHILIP S. JOHNSON.

August 2, 1828.—30 tf

When slaves ran away, as many did, they effectively reduced the assets of the people who owned them. In an effort to retrieve their valuable property, slave owners placed advertisements in newspapers offering rewards for the slaves' return. Ordinary citizens, hoping to claim the reward, would stop any black person and demand to see proof of their free status. If no proof was given, the slave was returned to the owner or placed in the local jail until the owner claimed him and paid the reward and the cost to the jailer for housing and food. In addition, slave owners' efforts to reclaim their property gave rise to a new occupation: the professional slave catcher. In these advertisements, George Nelson is seeking the return of his slave Cleary, and Phillip Johnson is hoping to reclaim his slaves Sam and Tom.

Brister Grigsby was born about 1825. He married Nancy Glascock, who was born in 1820. They lived in Morganton and belonged to Mount Nebo Baptist Church; only four of their six children survived infancy. Brister purchased 10 acres of land from Ann Morgan, the widow of former slaveholder William Morgan. This was the beginning of a profitable farm, which his descendants currently operate. He died in 1889, leaving the property to his wife and a daughter.

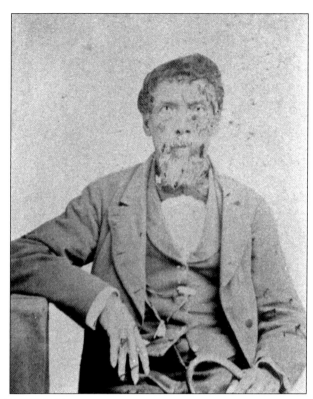

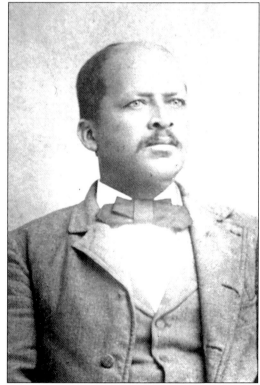

Gilbert Grigsby, born in 1855, was a son of Brister and Nancy Grigsby. On July 27, 1876, he married Martha Simmons. Prior to his father's death, Grigsby was allotted property to farm in exchange for the care of his aging parents and younger sister, Lillie. By 1905, he was working as a porter at Hotel Varnum in the District of Columbia.

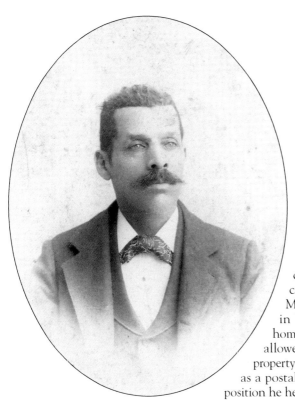

James H. Grigsby, born in May 1860, was a son of Brister and Nancy Grigsby. He married Caroline "Carrie" Welch, a daughter of Henry and Margaret Welch, on January 18, 1881. Carrie was born in September 1864. They had six children. James was the second recorded clerk of Mount Nebo Baptist Church in Morgantown. He worked as a farm laborer in Fauquier for his father and received a homestead deed in 1888. A homestead deed allowed Virginia landowners to protect their property from creditors. By 1910, James was working as a postal carrier in the District of Columbia, a position he held until his death in 1927.

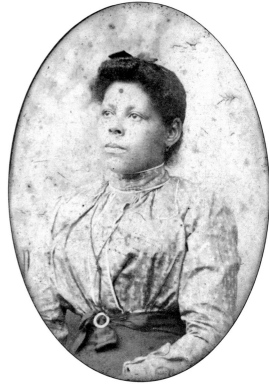

As a child, Peter Grigsby was enslaved by William Morgan. He was born in March 1855 to Brister and Nancy Grigsby. He owned and operated grocery stores in Morgantown and in West Virginia. He formed a business partnership with William F. Oliver, for whom Oliver City, a settlement of African Americans in Fauquier, is named. Peter preceded his brother James as a clerk of Mount Nebo Baptist Church. Lucy Catherine Gaines Grigsby, born in 1856, was a daughter of Watson and Elvira Gaines. She married Peter on April 20, 1881, and Wormley H. Hughes performed the ceremony. They had two daughters and a son. Lucy lived in Morgantown, owned property in the District of Columbia, and held membership in Salem Baptist Church in Marshall.

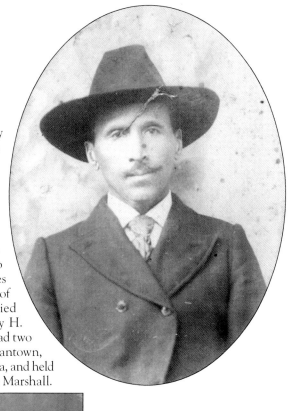

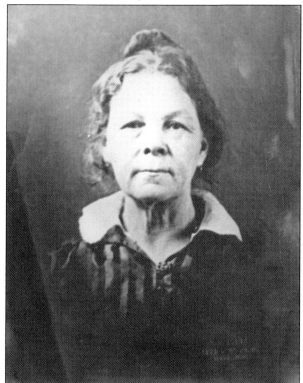

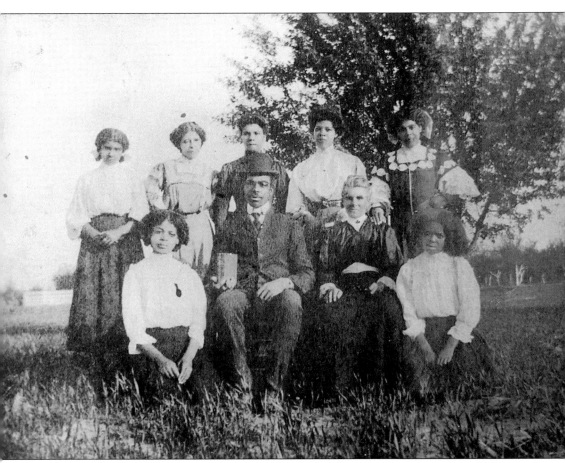

Grant Thaddeus Tyler, a son of George and Marjorie Chapman Tyler, was born in 1854. His wife, Clara Steptoe Blackwell, was born in 1855. One of the slaves emancipated by Elizabeth Blackwell, Clara was the daughter of Milly Blackwell and the granddaughter of Milly's slave owner/father, Armistead Blackwell. Grant and Clara were married in 1878 and were the parents of eight daughters and two sons. The sons died in infancy. They are pictured here with seven daughters. From left to right are (first row) Esther Eva, Grant, Clara, and Etta Edith; (second row) Florence, Lucy, Annie, Julia, and Lelia. (Lucy and Lelia are twins, as are Esther and Etta.) Grant, a teacher and a deacon at Ebenezer Baptist Church, proudly holds the Bible given to him by the deacon board.

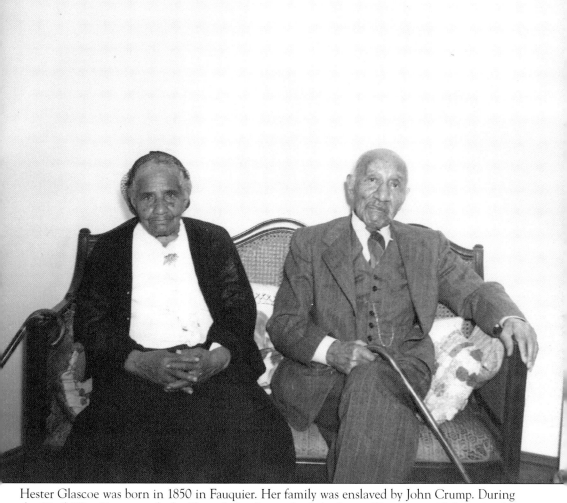

Hester Glascoe was born in 1850 in Fauquier. Her family was enslaved by John Crump. During the Civil War, Crump took the Hester's family south of the James River to avoid detection by Federal troops. When the war ended, the Crumps brought her back to Fauquier, but she wanted to be free of her enslaver. At 18, Hester married Henry Glascoe and moved to Culpeper County. Their only child, Henrietta, died in childhood. The Glascoes returned to Midland, where Hester worked as a babysitter for local families. She died in Midland in 1956 at 106. William Charlton Taylor, another former slave, was born in 1858 in Kentucky. After studying at Berea College, he moved to Prince William County, where in 1910 he was a farmer. By 1920, he was teaching in Fauquier but continued to live in Prince William with his wife and two daughters. Eventually, Taylor taught at and was principal of Fauquier's Rosenwald School. When Fauquier's new high school for African Americans was dedicated in 1952, it was named in his honor.

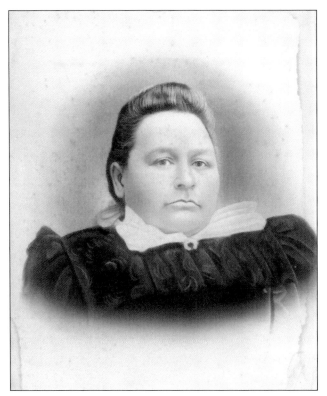

Edmonia Nelson Williams (1858–1941) was a daughter of Easter Nelson (1838–1931) and Lewis Edward Dulin, a white man. In 1871, she married Charles Lewis Williams, (1846–1922) a son of Louise Williams and Jack Rice. They had 10 children. Edmonia's mother, Easter, was enslaved by members of the Blackwell/Saunders/Dulin family of Rappahannock County.

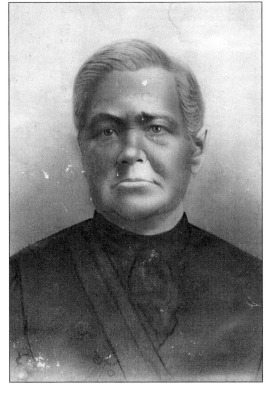

Mariah Miller Brown Berry was born in 1824 and died in 1898. During slavery, she married Peter Brown, and they were the parents of Lavinia, Carol, Sally, Annie, James, and Smith. Peter passed away, and after slavery, Mariah married Benjamin Berry. Her first freeborn child was Benjamin, who was born in 1870.

Sally Brown (1851–1934), a daughter of Peter and Mariah Miller Brown, married James Washington in 1867. The Washingtons partnered with Samuel and Ellen Taylor to purchase 5 acres of land on Seaton Mountain. There the Washingtons raised 15 children. They placed great emphasis on religious and educational training; the family became active members of Mount Olive Baptist Church, and the children attended school in Rectortown. Several family members migrated to pursue college and graduate degrees.

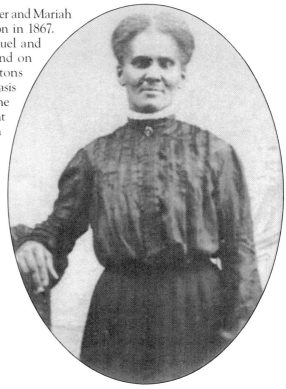

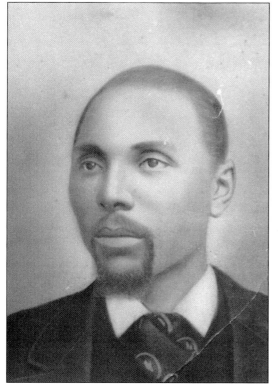

James Washington was born in 1847 to Henson and Fannie Jackson Washington. Fauquier County records indicate he was widowed when he later married Sally Brown. As an enslaved child, Washington was forced to assist the Confederacy. Mosby's Rangers, one of the most effective and feared clandestine Confederate units, established several safe houses in Fauquier. During their stays at the home of his owner, Washington hid their horses. He died in 1928.

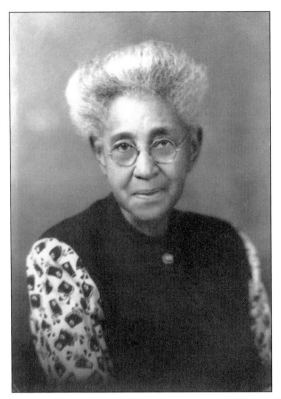

Sarah C. Reels, the daughter of Phillip and Mariah Wilson Reels, was born in 1860. In 1877, she married Oscar Washington, and they were the parents of four children. Oscar passed away, and she married Peter Gant on October 1, 1890. With Peter, she had nine children. Sarah died in 1953.

Peter, the second husband of Sarah Reels Washington Gant, was born in 1863 to Adam and Hannah Gant. By 1910, Peter, who worked as a farm laborer, had finished paying for his farm. By 1930, his home and property, located in The Plains, were valued at $3,000. The Gants were members of First Baptist Church in The Plains.

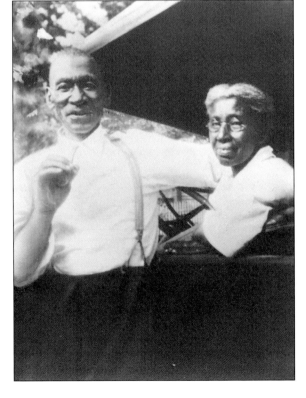

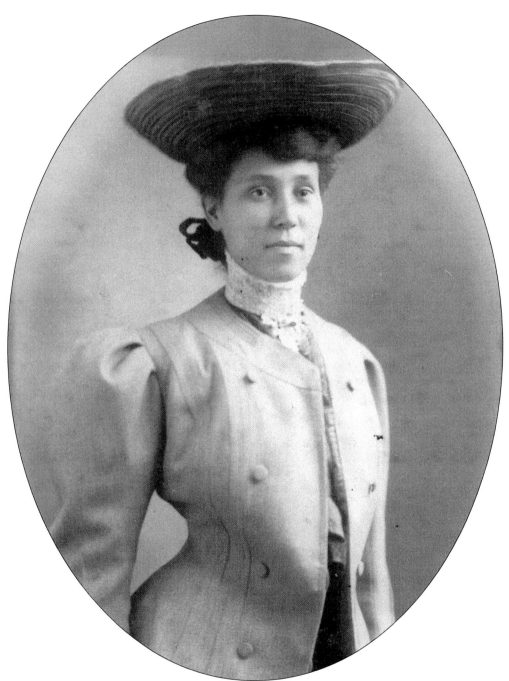

Margaret Holmes (1845–1897) was a daughter of Randolph and Belle Alexander Holmes. Their family was enslaved on a plantation owned by the Beale family. The relationship between the Beales and the Holmes did not end with slavery. In 1870, Margaret was a servant living in the home of William Beale. Margaret had a long-term relationship with Mortimer Weaver, a man of German descent. Her grandson, Robert Clifton Weaver, became the first African American cabinet member in U.S. history, serving as secretary of Housing and Urban Development during the administration of Pres. Lyndon Johnson. He later became president of Bernard Baruch College in New York City.

MARRIAGE LICENSE.

Virginia, Fauquier County to wit:

TO ANY PERSON LICENSED TO CELEBRATE MARRIAGES:

You are hereby authorized to join together in the Holy State of Matrimony, according to the rites and ceremonies of your Church, or religious denomination, and the laws of the Commonwealth of Virginia Gilbert Brown, and Bettie Gaunt.

Given under my hand, as Clerk of the County Court of Fauquier County this 31st day of July, 1872.

Wm. M. Hume, Clerk.

CERTIFICATE TO OBTAIN A MARRIAGE LICENSE,
To be annexed to the License, required by Act passed 15th March, 1861.

Time of Marriage, August 1st 1872.
Place of Marriage, Fauquier County, Va. Residence of John Iring
Full names of Parties Married, Gilbert Brown & Bettie Gaunt.
Colour, (Col'd)
Age of Husband, 21 years.
Age of Wife, 18 years.
Condition of Husband (widowed or single) Single
Condition of Wife (widowed or single) Single
Place of Husband's Birth, Fauquier Co. Va.
Place of Wife's Birth, Fauquier Co. Va.
Place of Husband's Residence, Fauquier Co. Va.
Place of Wife's Residence, Fauquier Co. Va.
Names of Husband's Parents,
Names of Wife's Parents,
Occupation of Husband, Laborer on farm

Given under my hand this 31st day of July, 1872.

Wm. M. Hume, Clerk.

MINISTER'S RETURN OF MARRIAGE.

I certify, that on the 7th day of _____ 1872, at _____ I united in Marriage the above named and described parties, under authority of the annexed License.

Cornelius Gaddis

☞ The minister celebrating a marriage is required, within TEN days thereafter, to return the License to the Office of the Clerk who issued the same, with an endorsement thereon of the FACT of such marriage, and of the TIME and PLACE of celebrating the same.

Gilbert Brown Sr., of Markham, was born around 1850. Bettie Gant from The Plains was born around 1854. In 1872, the Reverend Cornelius Gaddis, pastor of Mount Morris Primitive Baptist Church of Hume, married them. By 1880, the Browns were the parents of three sons and two daughters. Their great-grandson, Ronald Brown (1941–1996) was a trailblazer for African Americans: the first African American member of his college fraternity, the first African American partner at his Washington, D.C., law firm, the first African American chairman of a national political party, and the first African American to serve as Secretary of Commerce.

Two
Standing on the Solid Rock

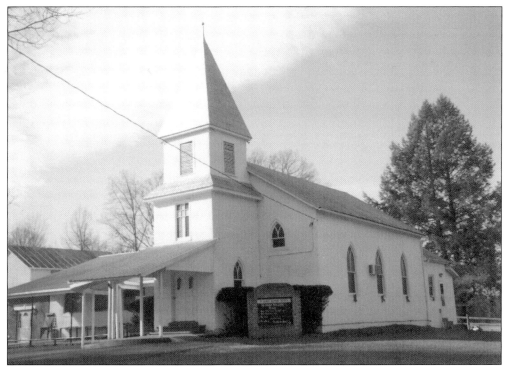

In 1866, Rev. Leland Waring (1816–after 1900) founded and became the first pastor of St. James Baptist Church. He led a group of believers who had been worshipping in a "bush arbor" in erecting a permanent structure, a building of hand-hewed logs with split-rail seats. With the assistance of his friend Lyttleton Jackson, who had been licensed to teach by the state, Reverend Waring began literacy classes at the church.

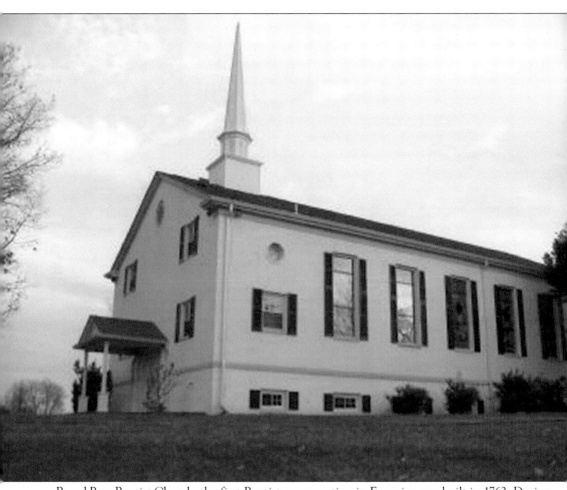

Broad Run Baptist Church, the first Baptist congregation in Fauquier, was built in 1762. During the Great Awakening (1730–1770), a period of intense religious fervor when emotion became more important than theology, slaveholders began to believe that it was their duty to expose their slaves to Christianity. Some hired people to preach to their slaves, some allowed slaves to preach, and others took their slaves to church with them. As early as 1764, there were African American members of Broad Run; in that year, according to minutes of the Broad Run Baptist Church from 1762 to 1782, "Negro Adam, belonging to Thomas Dodson" was dismissed to join a church in Halifax County. Later that year, "Negro Dick belonging to Joshua" was baptized. Among the slave members in 1819 were Judah, Rachel, Finder, Charity, George, Dick, Absalom, Jerry, Nora, and Gabriel. African American members of white churches were usually required to sit in the balcony and to take communion after white people had been served. After slavery, African Americans, seeking equality and autonomy, left white churches and established their own.

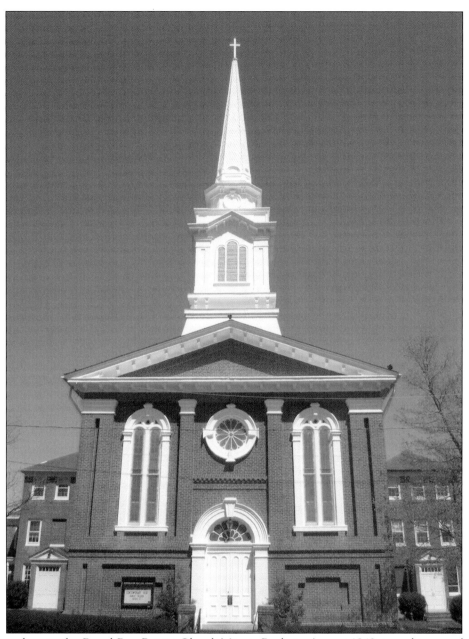

According to the *Broad Run Baptist Church Minute Book*, in August 1849, ten white members were dismissed from Broad Run Baptist Church to join the newly formed Warrenton Baptist Church. The following slaves were also dismissed for the same reason: "Secelia belonging to Baker, Mary Ann belonging to Leary, Milly belonging to Chapman, Sally belonging to Horner, Lucy belonging to Mrs. Baylor and Mary belonging to Mrs. Bragg." According to the Warrenton Baptist Church minutes, in July 1851, Anna, a slave of John Webb Tyler, a descendant of Pres. John Tyler, was accepted for membership at Warrenton Baptist. In November 1853, George, a slave of James Triplett, joined the church, and Milly Pryer, a slave of John Blackwell, joined in August 1856. Many of the former slave members of Warrenton Baptist Church formed Zion Baptist, First Baptist of Warrenton, and Mount Zion Baptist Church of Warrenton.

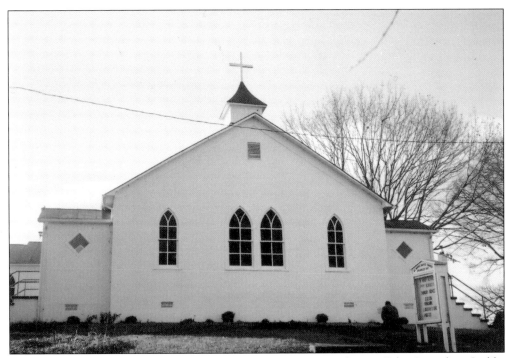

Mount Morris Primitive Baptist Church in Hume was organized in 1867 by Cornelius Gaddis (1825–1894). In 1847, Gaddis, Leroy Templeman's slave, presented a letter from the predominantly white Occoquan Church recommending him for membership at Thumb Run Primitive Baptist Church. Thumb Run, also predominantly white, is the mother church of Mount Morris and at least three other African American churches still in existence. Thumb Run's minute books reveal that Gaddis was dismissed from the church for running away from his owner. After appearing before the church and apologizing for his wrongs, he was readmitted. In 1869, John Clark, pastor of Thumb Run, granted written permission for Gaddis to preach the Gospel "to the brethren of his color." Licensed in 1871, Gaddis helped to organize Chestnut Hill Primitive Baptist, Mount Paran Baptist, and the Second National Ketoctan Primitive Baptist Association.

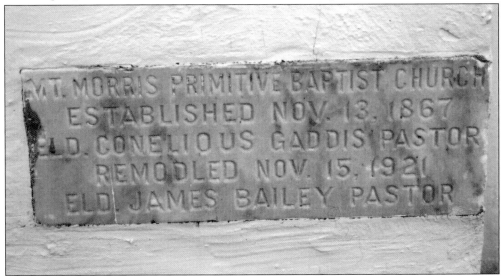

Whereas he Disobeyed God.

"The Church of Jesus Christ, at Union, Fauquier county, Va:—

TO ALL WHOM IT MAY CONCERN

Whereas, ANTHONY BURNS, a member of the church, has made application to us by a letter to our pastor, for a letter of dismission in fellowship, in order that he may unite with another church of the same faith and order; and,

Whereas, it has been satisfactorily established before us, that said Anthony Burns absconded from the service of his master, and refused to return voluntarily, *thereby disobeying both the laws of God and man* although he subsequently obtained his freedom by purchase, yet we have *now* to consider him only as a *fugitive from labor*, (as he was before his arrest and restoration to his master,) have, therefore,

Resolved, unanimously, That he be excommunicated from the communion and fellowship of this church.

Done by order of this church, in regular church meeting, this 20th day of October, 1855. W. W. WEST, Clerk.

Anthony Burns was a slave member when Zoar Baptist was called the Church of Jesus Christ. He escaped to Boston but after two months was located by his owner and arrested under the Fugitive Slave Act of 1855. The abolitionist community was upset and arranged for Burns's legal defense. Boston citizens were so angry that they stormed the courthouse and were met by federal marshals intent on returning Burns to slavery. During the ensuing riot, 13 people were arrested and a marshal was killed. At a cost of $40,000 to the federal government, Burns was returned to slavery. Abolitionists raised the funds to purchase Burns and set him free. Burns wrote to his church requesting a letter of dismission in order to join another church. The church responded by excommunicating him because by running away from slavery and refusing to return voluntarily he had disobeyed "the laws of God and man."

As was the case for most churches established by emancipated slaves, Ebenezer members began worshipping in "bush arbors," outdoor spaces with tree branches overhead as shelter from the elements. Ebenezer was founded in 1866 by an ex-slave named Henley Chapman and was formally organized in 1876. Those present at the organization were Charles Tyler, Randall Hunt, Jordan Sea, Sandy Chapman, Grant Tyler, Chapman Tyler, Enoch Tyler, Jane Richards, Elizabeth Pryor, Marjorie Tyler, Amy Jenkins, Henrietta Raymond, Lydia Pollard, Nanette Cook, Susan Robinson, Mariah Thompson, and Carolyn Pryor. The first services were held in the home of Millie Blackwell, a building she inherited from slave owner Elizabeth Blackwell. The church stands today on what was once Elizabeth Blackwell's plantation.

Rev. Enoch Daniel Tyler, a son of George and Marjorie Chapman Tyler, was born in 1855 and died in 1918. He was a grandson of Henley Chapman, one of the founding members of Ebenezer Baptist Church. Reverend Tyler served as pastor at Mount Pleasant and St. James Baptist Churches. His first wife was Eliza Downell (1857–1894), daughter of Willis and Charlotte. The Tylers were the parents of three daughters. Pictured here is Tyler's second wife, Queen Ann Elizabeth Fitzhugh (1876–1953), who was the daughter of Mary Fitzhugh. Queen was the mother of five daughters and one son, Rev. Elma D. Tyler, who also pastored churches in Fauquier.

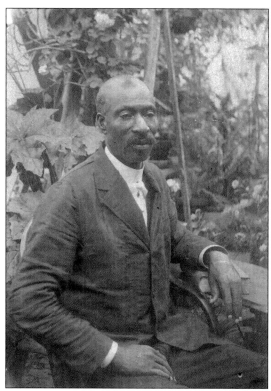

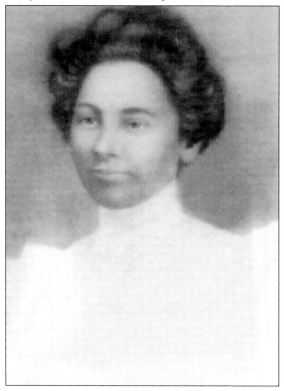

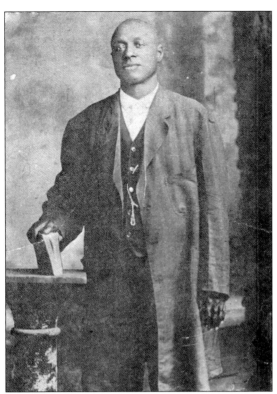

Rev. William A. L. Hancock, known as "the financial minister," began his tenure at Ebenezer Baptist Church in Midland in 1919 and served until 1925. He completed the building of the church and installed an organ. Rev. William H. Triplett (below) was Ebenezer's pastor from 1925 to 1948. He raised funds to have the church painted and to purchase a new lighting system. Through his initiative, altar chairs were purchased. The church's cornerstone was laid during Triplett's administration, and he also was responsible for organizing the Missionary Circle, Baptist Young Peoples Union, Young People's Club, Women's Club, Men's Club, the Busy Bees, and the Willing Workers' Club.

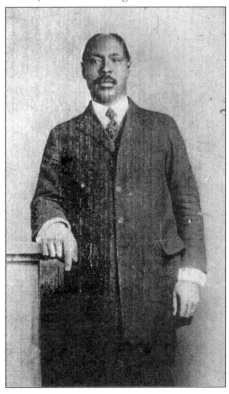

Former members of Zoar Baptist Church Alexander Morton, Marshall Hedgeman, George Hedgeman, Wilson Edwards, Willis Brown, and Allen and Harriet Gibson founded the Hearts Delight Baptist Church. In 1868, under the leadership of Jessie D. Howe and Noah Bumbrey, planning meetings for building the church began. Some of the nearby former slaveholders were opposed to the church being built but far more were supportive of the effort. In July 1894, Hearts Delight invited neighboring churches to a meeting to help them solve a problem that appeared to be of concern to the entire community. This invitation indicates the degree of cooperation and fellowship that existed among Fauquier County's African American churches. In 1909, the church held a service of dedication for its newly erected building in the Bristersburg, Sowego, and Catlett communities in southern Fauquier.

SOWEGO, VA. July 27th 1894.

The Hearts Delight Baptist Church
To the Ministerial & Deacon Union, of Tidewater, Virginia.
Dear Brethren:—
The Ministers of your body are invited and requested to come and sit in Advisory Council with us on Monday August 13th 1894. at 11 o'clock A.M. to advise with us concerning certain unhappy difficulties existing among us which are disturbing our peace and threatening the most serious consequences to the welfare of the church and the Christian ministry. The Council will be held at Hearts Delight. The following Churches are invited to sit with us:— Ebenezer, Silver Hill, Oak Shade, St. James, Mt. Pleasant, Oak Grove, First Brentsville, Mt. Zion and Shiloh. Trusting that all the Ministers of your body will please be with us on this occasion. Done by order of the church at its regular meeting for business.

Edw. D. Howe,
CHURCH CLERK.

Rev. V. Lacey, Pastor.

DEDICATION
Deut. 20:5.

The Dedication Services of the
Hearts Delight Baptist Church
will be held in the
CHURCH EDIFICE
SUNDAY, OCTOBER 24TH 1909.

PROGRAMME
11 a. m., A Paper "Historical Sketch."
11 30 a. m., Dedication Sermon by Rev. M. D. Williams, D. D., Manassas, Va.
2.30 p. m., Sermon by Rev. R. Jackson, Calverton, Va.

We extend a cordial invitation to all sister churches, their pastors, and congregations to attend these services.
We solicit your help, your presence, and your prayers.

TRUSTEES
J. D. Howe M. A. Gordon B. Blackwell

DEACONS
Alex. A. Morton Marshall Gordon J. Thomas Gibson

Williams Print, 1313 9th Street

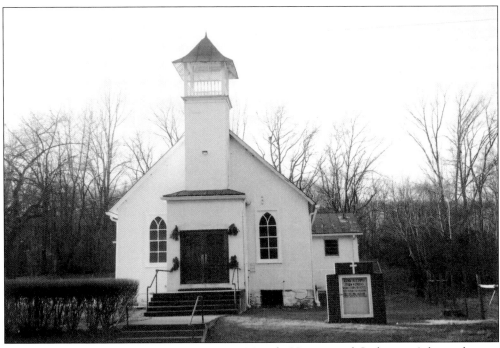

Mariah, Harriet, and Catherine Ash, residents of northern Fauquier, owned four male and three female slaves in 1860. In 1869, Harriet and Catherine willed their property to their former slaves and the surrounding community came to be known as Ashville. Harrison and Betty Robinson held prayer meetings in their home; from this activity the First Ashville Baptist Church in Marshall was born. The church was formally organized in 1874.

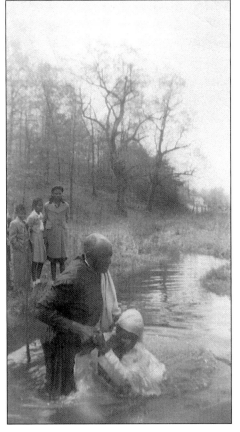

Rev. Arthur Stewart, a native of Rectortown, baptizes a congregant of First Ashville Baptist Church while Wesley and Doris Bolden and Thelma Robinson observe. The baptism took place in Carter's Run. Reverend Stewart also pastored at Mount Nebo Baptist Church in Morgantown. He was the son of Moses and Hanna "Anna" Stuart and was married to Janice "Jannie" Strother. He was born in 1881 and died in 1963.

The Northern Virginia Sunday School Convention was established about 1891 and was one of many groups that took a collective approach to problem solving. Outreach to those not committed to religion was a primary focus, as was education of the members. Creative approaches to fundraising were also common. Of the three officers listed at the bottom of the flyer, only Edward D. Howe, a teacher, was a resident of Fauquier.

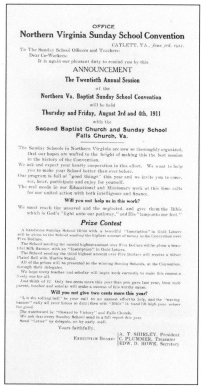

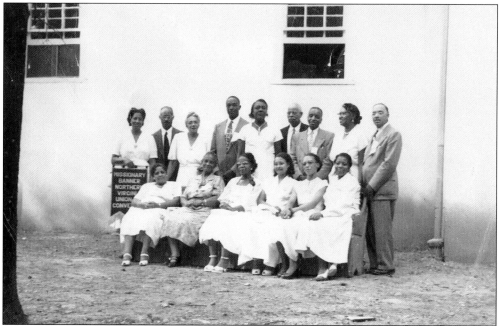

This photograph was taken in 1952 at Mount Pleasant Baptist Church during the Northern Virginia Missionary Association's convention. Pictured are, from left to right, (first row) two unidentified, Lydia Arnold, Mildred Hughes, and two unidentified; (second row) unidentified, Rev. Elma Tyler, three unidentified, Thomas Chapman Tyler, and three unidentified.

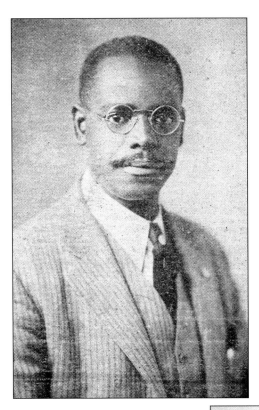

Nathaniel H. Johnson, the son of Julia and Nathan Johnson, was born in Markham in 1889. He was baptized at 12 and licensed to preach at 16 at Mount Olive Baptist Church in Rectortown. He studied theology at Virginia Union University and was ordained at Gethsemane Baptist Church in 1921. Johnson was pastor of Beulah Baptist Church in Markham, Mount Pisgah Baptist Church in Upperville, and Mount Vernon Baptist Church in Front Royal, Virginia.

Rev. Harry Benjamin Williams Sr. was born in Orlean, Virginia, on August 17, 1888, to Charles L. Williams Sr. and his wife, the former Edmonia Nelson. Reverend Williams married Ella S. Jeffries in 1906, and they had nine children. After ordination by the Second National Ketoctan Baptist Association, he pastored two churches simultaneously from 1943 to 1977. On the second and fourth Sundays, he held services at St. Paul Baptist Church in Happy Creek, Virginia, and on the first and third Sundays, services were held at Bethlehem Baptist Church in Fredericksburg, Virginia.

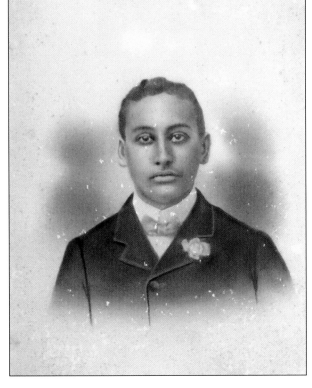

Bro. Spurgon Tyler of Cross-Roads Baptist Church will favor us with his service as Organist for the day

Rev. W. H. Triplett, Minister
Bro. B. W. Coles, Clerk

Men's Day
AND
ANNUAL RALLY
OF
SILVER HILL BAPTIST CHURCH
SUNDAY JULY 28, 1929

Pastors & Congregations of all Sister Churches are cordially invited to spend a day of Joy and Christian service with us.

Services begins promply at 11 A. M. & 2.30 P. M.

MASTERS of CEREMONIES
11 A. M. Deacon W. T. Neverdon
2-30 P. M. Bro. M. F. Coles

This was the program for the Men's Day and Annual Rally at Silver Hill Baptist Church, held in 1929. All churches and congregations were invited to participate in the service. Silver Hill was founded in 1869 in the Morrisville community. In 1885, Lucy P. Walker and Eloisa Sale, the wife of Robert Sale, who were heirs of Hannah Blackwell of Orange County, Virginia, deeded land to David Jackson, Horace M. West, and Thomas H. Coles. This land, between Morrisville and Crittenden Mill, was part of the Silver Hill tract of Hannah Blackwell's estate. Here the church was erected and named for the land on which it stood.

PROGRAM
11 A. M.

Opening Hymn Bro. F. W. Coles
Prayer Deacon J. A. Lee
Hymn Deacon B. W. Coles
Scripture Read by Deacon W. L. Washington
Prayer Deacon Bradley Coles
Hymn Bro John Gibson
Address Subject: God wants a Man
 Deacon J. D. Brown
Address Deacon T. C. Tyler
Solo
Address Bro. Samuel Carter
Address Bro. William Gibson
Remarks Deacon W. T. Thompson
Introduction of Visitors
Collection Lifted by Bros. G. D. Williams & Harrison Robinson
Benediction
 Dinner served on the Ground

PROGRAM
2.30 P. M.

Hymn by Bro. G. W. Taylor
Scripture Read Deacon W. C. Neverdon
Prayer Deacon White
Introduction of Master of Ceremonies by
 Deacon W. T. Neverdon
Hymn by Congregation
Address Bro. James E. Williams, L.L.D.
Quartet From St. Luke Baptist Church
 Washington D. C.
Address Rev. Arthur Chichester
 Subject: His delight among the sons of Men
Address Dr. George Richardson
 Subject: Better Citizenship
Introduction of Visitors
Collection & Report of Captains in charge of
 Deacon W. C. Neverdon
Benediction

Mount Olive Baptist Church developed from prayer meetings held in the Rectortown home of Charles and Julia Grant. The first building was completed by 1870; it was destroyed by fire and another was constructed. The cornerstone was laid in 1911. Rev. Richard Dawson supported the idea of using the building as a school. Mount Olive was one of the churches instrumental in the founding of the Northern Virginia Baptist Association.

Rev. Leland Waring organized First Baptist Church in Warrenton in 1867. The original site was on Lee Street, but when the congregation expanded, the church moved to its current location, which was formerly a Presbyterian church, on Alexandria Pike. The church also housed a school, and Mrs. Doram was the first teacher.

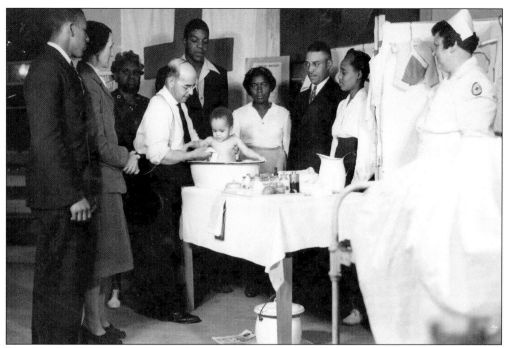

The African American church has always concerned itself with the spiritual, emotional, educational, economic, and physical well-being of its members. These photographs depict lessons in child and patient care offered at Cross Roads Baptist Church under the auspices of the Red Cross. Above, the pastor, Rev. Joseph Hackett, demonstrates the proper way to bathe an infant. Pictured from left to right are Charles Chapman, Hazel Oliver Chapman, Bessie Bumbrey, Elwood Arnold, unidentified, Thomas Chapman Gibson, unidentified, and an unidentified Red Cross nurse. Below, from left to right, Ella and Mary Chapman, Daniel and Emma Dishman, Spurgeon Tyler, and Bessie and Fred Bumbrey surround Lydia Arnold, the patient. The church was established in 1909 and built on land donated by Rev. Chapman Marshall Tyler and his wife, the former Fannie Oliver.

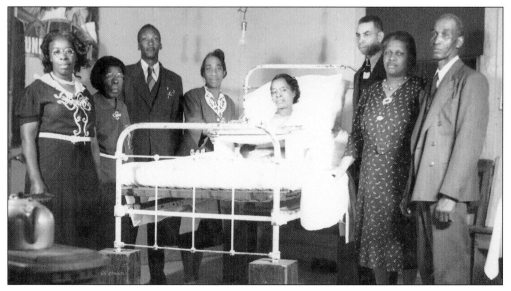

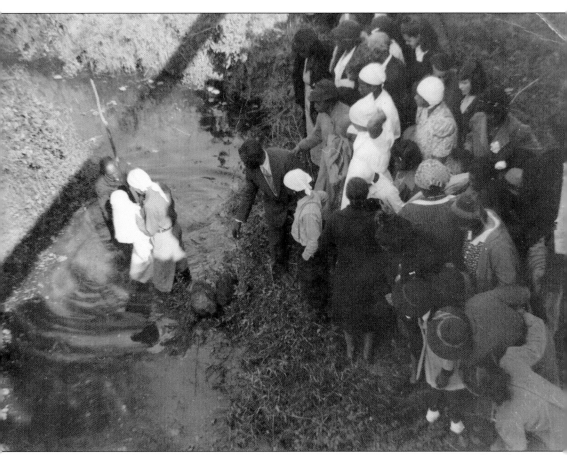

In years gone by, many activities in the African American community were shared across neighborhood boundaries. Churches, schools, and other organizations shared in each other's services and rituals. It was also common practice to work collectively to prepare for certain events. To get ready for baptisms, fences were erected to keep animals away from the baptismal site. The waterways were dammed overnight to insure adequate water for the ritual. Here Pastor Sherman W. Phillips baptizes members of the Salem Baptist Church congregation in Carter's Run. The church was built of timber from Morgantown's wooded lots, with Robert Ross providing most of the labor. In 1961, Salem Baptist celebrated Pastor Phillips's 35 years of service to the church and the Rosstown community.

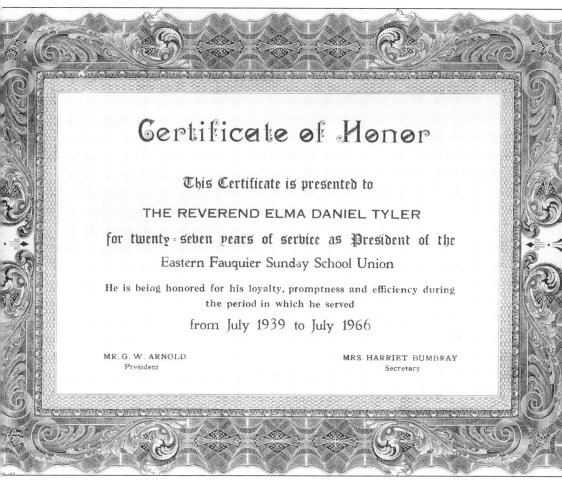

This certificate was presented to the Reverend Elma Daniel Tyler, son of Rev. Enoch Daniel and Queen Ann Elizabeth Fitzhugh Tyler, for his many years of service in the religious arena. The Eastern Fauquier Sunday School Union was established in 1910 as a mechanism for improving and enhancing religious activities for the youth of the community. The union grew out of concerns expressed by members of Oak Grove Baptist Church. The first president was Rev. Natus Washington. A committee appointed to select speakers to present topics of interest to the group included George M. Taylor, Charles H. Wanzer, and William T. Neverdon.

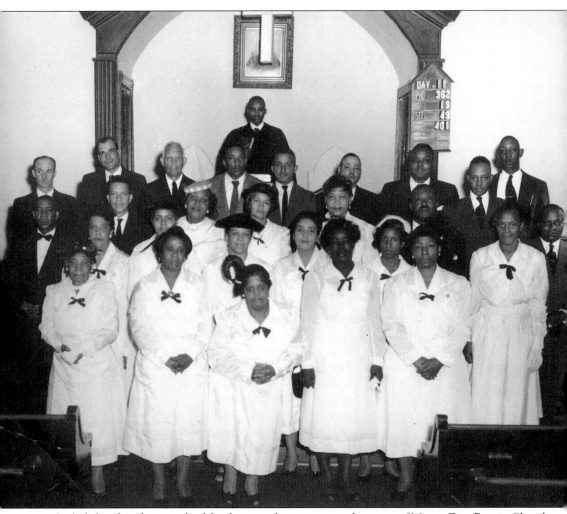

Included in this photograph of the deacons, deaconesses, and trustees of Mount Zion Baptist Church in Warrenton are, from left to right, (first row) Lucy Preston, Bennie Russell, Ada Matthews, Ruth Walker, Agnes Cephas, and Estelle Vowles; (second row) Bessie Wheeler, Elizabeth Williams, Alice Walker, Mary Murray, and Winnie Walker; (third row) Edward Cephas, George Walker, Eva Bratcher, Luvenia Hughes, Lena Ford, William Bratcher, Morris Walker, and Clarence Curtis; (fourth row) Clarence Dade Sr., Albert Campbell, Hampton Murray, William Peyton, Chester Jones, Mosby Williams, James Walker, and John Matthews. The pastor was Rev. Ernest Cunningham. In a deed dated July 15, 1884, Rice W. Payne and his wife, Virginia, sold a parcel of a lot situated between South Fourth and Lee Streets in the town of Warrenton to trustees Polk Rose, P. S. Ball, Albert Fry, John Fry, and E. L. Sheppard of the Mount Zion Baptist Church for $500. The trustees paid $150 that day, with a lien on the church for two notes of $175 each and interest due every two years.

Asbery Roszell Pinkett (1854–1918) was born in Loudoun County to Henry and Ann Anderson Pinkett. He married Mary Jackson in 1872 and Lucy Whittington in 1886. Pinkett pastored six Baptist churches, three of which were in Fauquier County: Providence in Orlean, Zion in Montville, and Mount Nebo in Morgantown. He was ordained at Providence.

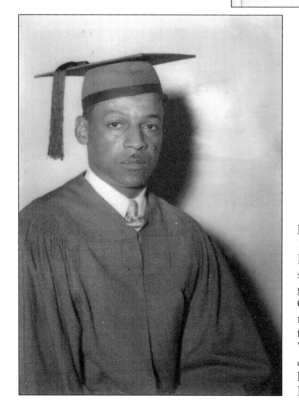

Rossell Stonewall Jackson was born in 1913 to Beverly and Catherine Georgetta Pinkett Jackson. He attended elementary school in Morgantown and Bethel and graduated from Virginia Seminary and College in Lynchburg, Virginia. He received the doctor of divinity degree from a seminary in Baltimore, Maryland. When he died in 1977, he was pastor of the New Grove Baptist Church in Kenbridge, Virginia, and Mount Nebo Baptist Church in Morgantown, Virginia.

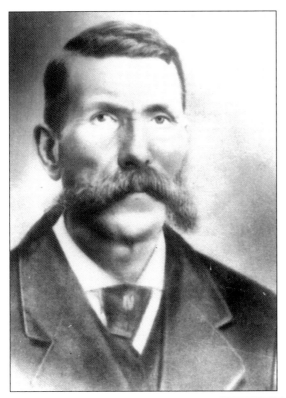

Mark "Marcus" Russell (1838–1929) was born to Frances "Fannie" Brown Weldon, a free woman of color, and William Russell, a white man. He was the second pastor of Mount Morris Primitive Baptist in Hume, succeeding Cornelius Gaddis. Services were held on the second and fourth Sundays of each month, and membership increased greatly during his tenure. He also pastored at Poplar Fork Baptist Church. He established a dynasty of Fauquier County ministers.

A second-generation minister, Murray S. Tapscott, the son of Mark Russell and Cordelia Tapscott, was born in May 1864. Initially he was an itinerant evangelist, but eventually he became pastor of Little Zion Baptist Church in Greenville. He married Kate Colvin in 1885, and by 1900, they had eight children. They were the parents of 12 by 1910. He died on September 27, 1937.

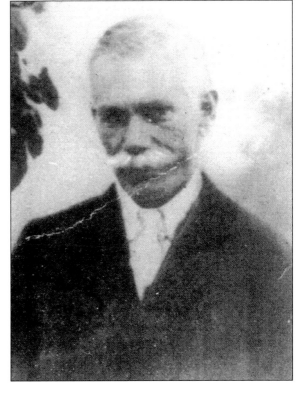

James Murray Tapscott was born on March 19, 1893, to Murray S. and Kate Colvin Tapscott. After serving in World War I, he was ordained in 1936 to preach the Gospel. He also was sent out to evangelize. He pastored the Church of God in Warrenton and the Church of God in Opal. He was the third generation of his family called to the ministry. He died on July 10, 1982.

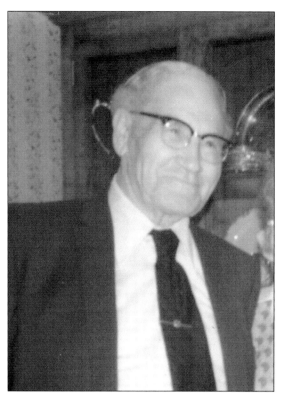

The fourth generation is represented by James Robert Tapscott, who was born in 1928 to James M. and Roberta A. Tapscott. He was called into the ministry and was licensed under the leadership of Rev. James Brown of the Waterloo Baptist Church in Waterloo. He was ordained by the Second National Ketoctan Baptist Association and became pastor of the Ebenezer Baptist Church in White Post, Virginia. He died in 2005.

Dr. Decker H. Tapscott, a fifth-generation minister in his family, was born to James Robert and Alease Smith Tapscott. He is the founder and senior pastor of Faith Christian Church and International Outreach Center, a rapidly expanding multicultural church on the outskirts of Warrenton, Virginia. Dr. Tapscott is a product of the Fauquier County public school system. He received a doctorate in ministry degree from Logos Christian College and Graduate School in Jacksonville, Florida. He has written numerous books and also ministers through a television broadcast. Dr. Tapscott and his wife, Delores, currently live in Warrenton. Perhaps one of his six children will be the sixth-generation minister in the family.

Three
LET THERE BE LIGHT

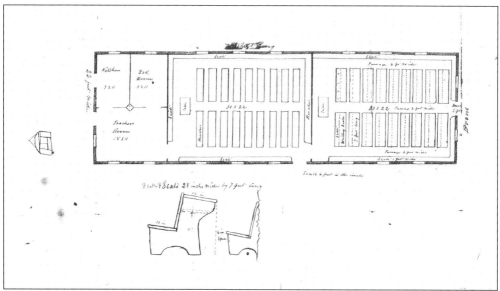

The Bureau of Refugees, Freedmen, and Abandoned Lands, a federal agency known as the Freedmen's Bureau, provided food, clothing, and medicines to the freedmen, oversaw labor contracts between them and white employers, and redistributed lands abandoned by white Southerners. Perhaps its most significant contribution was the establishment of schools for the freedmen. Pictured here is a drawing of the interior of the Freedmen's School in Warrenton.

The Ku Klux Klan was organized in 1865 by Confederate veterans who wanted to restore white supremacy in the South. They used violence to intimidate and subjugate African Americans, Jews, Catholics, labor union members, and sympathetic whites. Freedmen's Bureau records document Klan activity in Fauquier in 1867 when Edward Davis "was knocked senseless with a shovel by Gustavas Creel and awakened to find his feet burning in the fireplace." In 1868, Morton Havens wrote to Freedmen's Bureau officials describing violence against an African American man and the defacing of an African American school. The Blackwelltown Protection Society and Literary Club worked for enhanced education and promoted literary, religious and political activities, especially among young African American men. Perhaps the "protection" aspect of the title was in response to Klan violence.

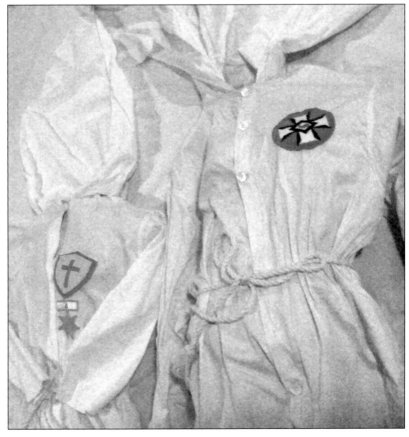

[Ed. Form, No. 3.]

TEACHER'S MONTHLY SCHOOL REPORT

For the Month of January, 1868.

☞ To contain one entire calendar month, and to be forwarded as soon as possible after the close of the month.
☞ A School under the distinct control of one Teacher, or a Teacher with one Assistant, is to be reported as one School.

[Answers placed here.]

Question	Answer
Name of your School?	Warrenton Freedmen
Location (town, county, or district)?	Warrenton Va.
Is it a Day or Night School?	Both
Of what grade?	It is a mixed school, therefore not graded
When did your present session commence?	Oct 23d
When to close?	June 30th 1868
Is your School supported by an Educational Society?	In part
What Society?	A.E. Brm. Fr. Un. Commission
Is your School supported wholly by local School Board?	No
Name of Board or Com.?	
Am't pd. this month?	
Is your School supported in part by local School Board?	No
Name of Board or Com.?	
Am't pd. this month?	
Is your School supported wholly by the Freedmen?	No
Amount paid for this month?	
Is your School supported in part by the Freedmen?	Yes
Amount paid for this month?	$16.80
Have you had Bureau transportation this term?	Yes
Who owns the School-building?	Bureau
Is rent paid by the Freedmen's Bureau?	No
How much?	0
What number of Teachers and Assistants in your School?	1
White?	1
Colored?	0
Total enrolment for the month?	103
Male?	64
Female?	39
Number enrolled last report?	110
Number left school this month?	21
Number new Scholars this month?	14
What is the average attendance?	50 day school, 15 night school
Number of Pupils for whom tuition is paid?	55
Number of White Pupils?	0
Number always present?	19
Number always punctual?	16
Number over 16 years of age?	24
Number in Alphabet?	5
Number who spell, and read easy lessons?	50
Number in advanced readers?	48
Number in Geography?	5
Number in Arithmetic?	56
Number in higher branches?	0
Number in Writing?	63
Number in Needle-work?	0
Number free before the war?	8
Have you a Sabbath-School?	No
How many Teachers?	0
How many Pupils?	0
Have you an Industrial School?	No
Number of Pupils?	0
State the kind of work done?	0

☞ To the following questions give exact or approximate answers, prefixing to the latter the word "about."

1. Do you know of any Schools for Refugees or Freedmen not reported to the State Superintendent? Yes. How many? 1
2. Give (estimated) whole number of pupils in all such Schools? 80 No. of Teachers. 1 White. 0 Colored. 0
3. Do you know of Sabbath Schools not reported to the State Superintendent? No How many? 0
4. Give (estimated) whole number of pupils in all such Schools? 0 No. of Teachers. 0 White. 0 Colored. 0
5. State the public sentiment towards Colored Schools. While some people are friendly, the community would close them
6. How many pupils in your School are members of a Temperance Society? 1 Name of the Society? Lincoln Temperance Society

Remarks. There is a school organization here, but not such as is referred to in the blank.

(Signed) George H. Morse

George Morse, a white man, was the teacher at the Freedmen's School in Warrenton. In his monthly report he provided statistical information about his pupils, their attendance and performance, and subjects being taught. In a separate statement to officials of the Freedmen's Bureau, he described the negative manner in which some of Fauquier's white citizens reacted to his efforts to educate African Americans. There were several incidents during which Morse was verbally harassed and intimidated and one in which he was physically threatened by a group of men who threw stones at him. It seems likely that if the teacher was threatened, the pupils and their parents must have been also. In addition, African Americans faced economic reprisals, such as job terminations, for their efforts to learn. Nevertheless, acquiring education was the primary objective of African Americans who had been denied that privilege before the Civil War.

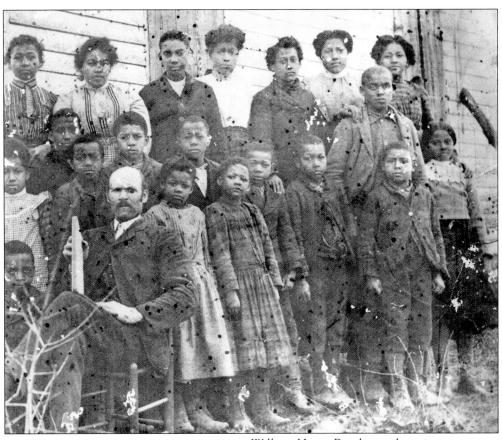

William Henry Brooks was born in Rappahannock County to Roxaline Gaskins and Joseph Colbert, a white man. Roxaline later married George Brooks, and William adopted his surname. After William was educated in Virginia, Colbert paid for his studies in Pennsylvania. Brooks was certified to teach in Orlean in 1901. In 1881, Brooks married Mary Jane Carter, and they were the parents of 12 children. This photograph and roll book are from the Orlean School, where Brooks taught.

58

Anthony Dangerfield's daughters taught at the Hume School, which was built on his land. Mary Virginia "Jennie" (seated), born in 1869, was the daughter of Dangerfield's first wife, Virginia Mary Jones. Educated at Lynchburg Seminary, Jennie married Edward King and moved to Philadelphia. Sarah Mildred "Minnie," born in 1877, was the daughter of Dangerfield's second wife, Jane Moore. In 1897, she married Robert Russell and moved to Connecticut.

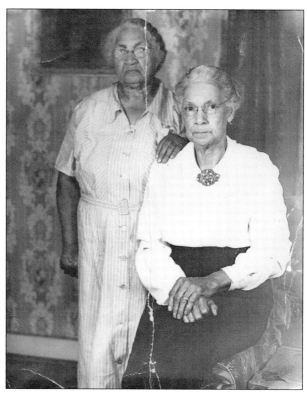

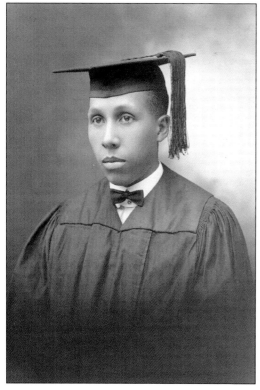

The 10th child of William Henry Brooks Sr. and the former Mary Jane Carter, Aldridge Brooks was born in 1899. As a child he attended the school in Orlean where his father was the teacher. He moved to Harrisburg, Pennsylvania, and married Fannie Lee. Brooks was a graduate of Lebanon Valley State Teachers College.

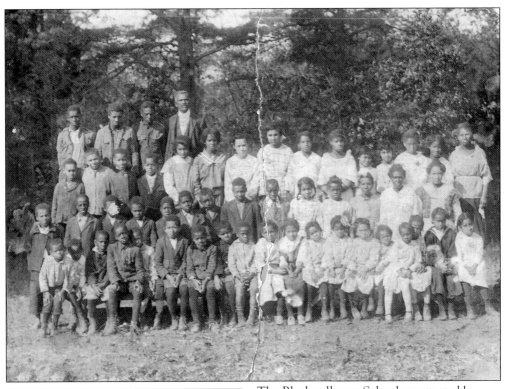

The Blackwelltown School was started by Ebenezer Baptist Church in the Midland community. The teacher pictured here, Thomas W. Thompson, was born in 1868 and worked as a farmer before beginning his teaching career. This graduation ceremony took place in April 1892. Thompson was apparently intent on giving every pupil in the school a chance to shine. This was a strategy that served to develop parental pride and increase community support for the activities of the school. In the accompanying photograph are Thomas Thompson (back row); Eva Blackwell (third row, fourth from right); Viola Blackwell (second row, fifth from right); and Elna Edwards Neverdon (first row, at right), probably the only surviving Blackwelltown School student.

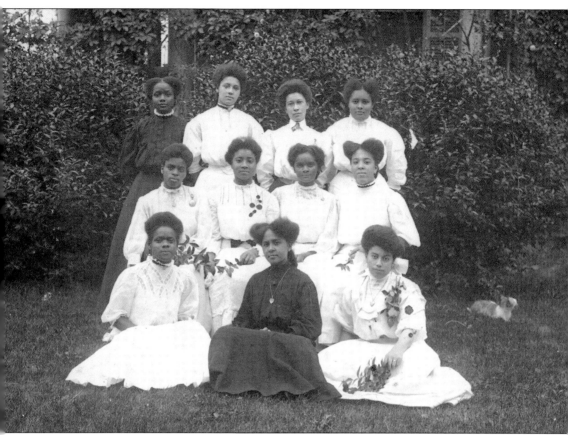

In this photograph of the Spelman Seminary (now College) class of 1908, Esther Williams Tyler is seated on the first row at left. She was a native of Clark County and a 1904 graduate of Hampton Institute (now University). Following graduation from Spelman, she taught in Florida for nine years. In 1917, she became the first Jeanes Teacher in Fauquier County, a position that involved training other county teachers, raising funds to build Rosenwald schools, and fostering community involvement in school-improvement projects. After marrying Fauquier native Thomas Chapman Tyler, she retired from classroom teaching but continued to teach and assist community members through church and volunteer activities. She organized sewing clubs so women with limited funds could afford to look nice when they attended church. When an African American high school was finally built in Warrenton, the county would not provide transportation for students in the rural areas. The Tylers took a leadership role in raising funds to buy a bus and to pay a driver so that children from Catlett, Calverton, and Midland could regularly attend school.

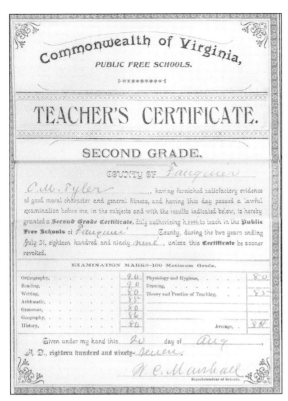

In order to teach, Rev. Chapman Marshall Tyler had to pass an examination administered by the Commonwealth of Virginia. His grades are especially impressive for a man who was born in slavery and had no formal education until after emancipation. Two of his brothers and four of his 10 children were also educators in Fauquier County. In most subjects, 11-year-old fourth-grader Turner Gibson, one of Chapman Tyler's students, showed improvement in spite of the fact that the school year was only four months long. The semesters were longer for white students. In this way, African American children were available to work on family farms or to be hired by white farmers and help supplement the family income.

Catherine, a daughter of Boynton and Catherine Bell, and Fred, a son of Alexander and Mary Bell, were students at Murray's Cross Roads School. The school was established by Cross Roads Baptist Church, which was organized in 1909 by a group of people who met at the home of Charles Wanzer for Sunday school. Originally, classes were held in the church or in the home of the pastor/teacher, Rev. Chapman Marshall Tyler. In 1915, the school, a one-room frame building with a metal roof, was erected on land that Tyler and his wife, Fannie, deeded to county school authorities. The classroom was equipped with pencil sharpeners, tools, cooking utensils, dishes, globes, maps, and a flag. The school was heated with a wood-burning stove, and water was available from a nearby pump.

> Casanova Va.
> Feb. 15, 1912
>
> My Dear Teacher,
> January is frist month in the year. Feb is the shortest month in the year. March bring cold winds. April showers bring may flowers. June is the month of roses. September is the harvest month. October brings bright red and yellow leaves. Christmas come in December.
>
> Catharine P. Bell
> Casanova
> Virginia

> Casanova Va.
> Feb 9 1919
>
> My dear teacher
> One day a mouse run over the lion nose and woke him up. The lion put his paw on the mouse the lion was redy to crush him up. but the mouth beged so hard that the lion let him go
> One day sun men caught him in a net the mouse came along and saw him he soon get him out
> From Fred Bell
> Rev C M Tyler
> RT 1 Box 59

> "Ho, everyone that thirsteth come ye to the water.— Isa. 51:1.

WHERE THE
Fauquier Central Teachers Union

Will hold its next session with the

BLACKWELL TOWN SCHOOL, NO. 5,

Midland, Va., May 6, 1910.

MR. G. W. THOMPSON, Teacher.

A FREE INVITATION TO ALL.

PROGRAMME.

10:00 a. m.—Devotional Exercises by the President or some one appointed by him. Welcome address, reading of minutes, appointment of committees.

10:30 a. m.—A paper, subject "The Co-Relation of the Church to the Public School," by Rev. E. D. Tyler.
Discussion of Subject.

12.00 M.—Recess.

1.30 p. m.—Introduction of educators and visitors.
A paper, subject "How to Teach History and Geography by Mrs. Lucy McClellan.
Discussion of Subject.
A paper, subject "Can a Race Rise to Eminence Without Education," by Rev. T. T. Hedgman.

OFFICERS:

Prof. F. H. Brooks, Pres. Rev. C. M. Tyler, Vice-Pres.
Mr. T. W. Thomson, Sec. Mr. M. T. Tyler, Asst. Sec.

The primary purpose of the Fauquier Central Teachers' Union was to enhance the skills of county teachers. In an era when schools for African Americans were physically inferior to white schools and were disproportionately underfunded, community support was of utmost importance. Therefore, a secondary purpose of the union was to involve all levels of the community in the education of the students. At this time in African American history, many who worked in the field of education viewed their employment as a religious obligation to the students and their communities, as evidenced by the biblical quote at the top of the flyer and the participation of ministers in the program.

Robert Emmett Miles taught at Morgantown School from 1892 to 1930. He was born in 1858 to Enoch Smith, a slaveholder, and Hester Miles. Miles and his wife, Kittie, the daughter of Henry and Margaret Welch, and their children lived in the Morgantown community. Below, seated on the schoolhouse steps, are Miles's grandchildren, from left to right, (first row) Leon Hardy, a grand-nephew, and Ferdinand; (second row) Lillian, Bessie, and Marjorie. After Kittie's death, Miles married Lue Williams, a Sunday school teacher. The Miles property provided the students with drinking water from their spring from the 1890s until the school closed with the opening of Northwestern Elementary in the 1964–1965 school term.

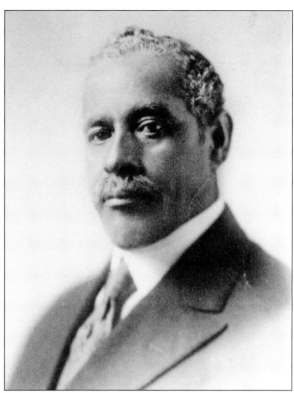

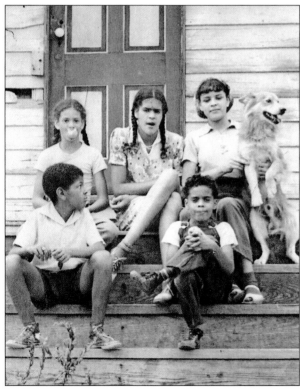

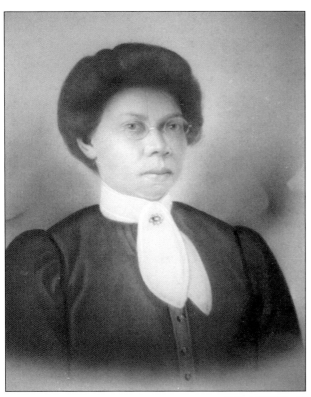

Georgetta Burbridge Hughes was born in Pittsburgh, Pennsylvania, in 1865. While teaching in Loudoun County, she met Wormley Hughes. They married and relocated to the Morgantown/Orlean area of Fauquier. She taught at Delaplane School, at Morgantown School, and at schools in Prince William and Warren Counties. Wormley was a preacher in Loudoun County and at Mount Nebo in Morgantown and Providence in Orlean. He was the son of Rev. Robert Hughes, the grandson of Wormley Hughes (his namesake), the great-grandson of Elizabeth (Betty) Hemings, and a great-nephew of Sally Hemings. Following Wormley's death in 1901, community members cared for Georgetta's five children so that she could continue to teach and provide support for her family.

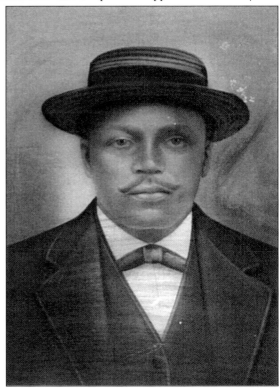

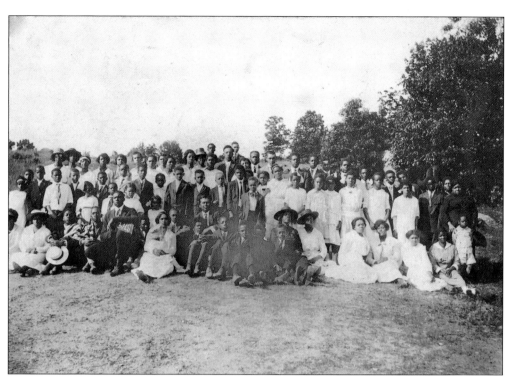

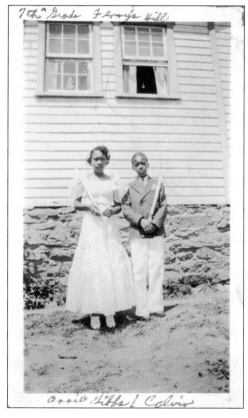

Adults and children at the Fenny's Hill School in the area known as Sage are pictured above. The property on which the school was built was donated by Gillison Wanser. Like noted educator and founder of the Tuskegee Institute (now University) Booker T. Washington, Wanser believed strongly that hard work, religion, and education were the keys to progress for African Americans. Fenny's Hill School provided a venue for educational achievement to the Wanser, Gaskins, Pendleton, Green, Haley, Webb, Baltimore, Warner, and Walden families. At right, Annie Gibbs and Calvin Wanzer, seventh-grade graduates, proudly display their diplomas in front of the school.

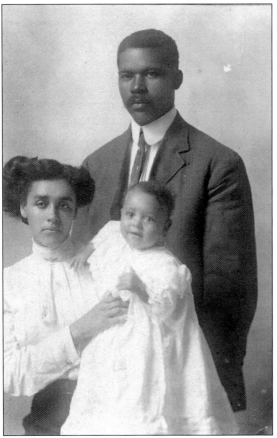

Pictured are David Steptoe Jackson; his wife, the former Isabelle Wanser; and their son Langsford. Isabelle was a daughter of Gillison and Annie Gaskins Wanser. Jackson, who was born in Northumberland County, Virginia, was a carpenter who built numerous homes in the Ashville and Sage communities. He also taught at Ashville and Fenny's Hill Schools. Jackson's spring supplied drinking water for the students. The building pictured above replaced the Little Red School, which was burned by angry whites who attempted to suppress the education of African Americans. There were three generations of teachers in the Jackson family, including their daughter Carrie, a Fauquier County educator in the era of one-room schoolhouses.

Charles L. Williams Jr., the third child of Charles L. Sr. and Edmonia Nelson Williams, was born in 1878. A graduate of Kalamazoo College in Michigan, he taught at the Ashville School. In addition, he was a farmer with 80 acres of land and a lifelong bachelor. Williams died in 1964.

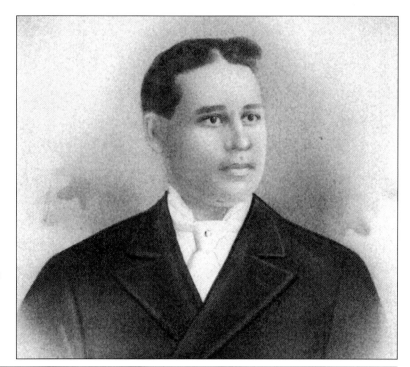

Mildred Hughes, the daughter of John Henry and Mary Wanser Hughes, was born in 1924. Mildred grew up in the community of Ashville and attended the Ashville School; she graduated in 1938. Across the dirt road from the school was the Ashville Baptist Church, of which Mildred was an active member.

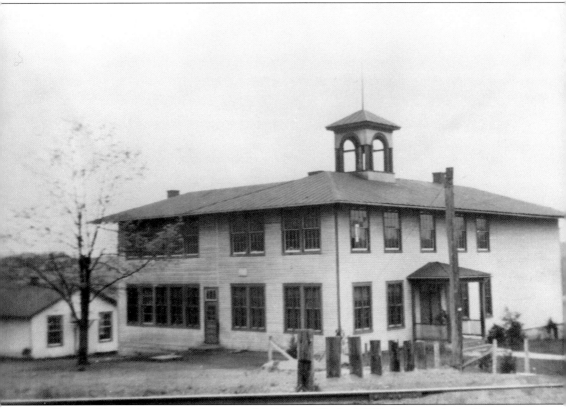

Rosenwald schools grew out of a partnership between Booker T. Washington, the leading proponent of industrial education, and Julius Rosenwald, a philanthropist and president of Sears, Roebuck, and Company. The two worked together to improve educational conditions in rural schools. Rosenwald donated millions for the construction of buildings on two conditions: that African Americans raise a portion of the money needed and provide construction labor and that the local school board would make the new building a part of the public school system. In this way, more than 5,000 schools were erected in 15 southern states, 381 of them in Virginia. There were one- and two-room Rosenwald schools erected in Blackwelltown, Crest Hill, Greenville, Orlean, Rectortown, Remington, and Routts Hills. In 1932, Rosenwald funds financed the erection of Fauquier's first high school for African Americans.

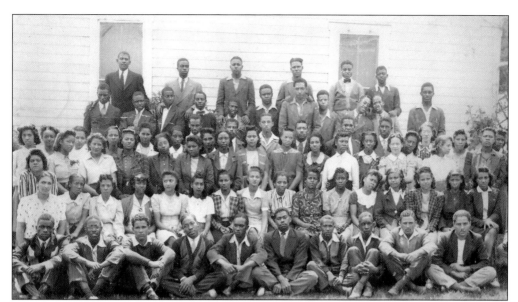

The Manassas Industrial School, chartered by Virginia in 1893, was the realization of Jane Serepta (Jennie) Dean's vision of providing residential education for Northern Virginians over age 14. Like Booker T. Washington, Dean sought financial contributions from northern philanthropists. The school offered mathematics, science, geography, physiology, music, literature, and English in addition to carpentry, blacksmithing, shoe making, cooking, sewing, and other trades. It survived as a private institution until 1938, educating more than 6,500 students from Virginia, Washington, D.C., and other states. It became an accredited high school, funded and operated by the Commonwealth of Virginia. Until 1932, Fauquier's African American students were unable to earn diplomas at home, so many were students at Manassas Industrial School. Pictured here are the commencement program and students of the class of 1941. Diplomas were awarded for academic, agricultural, and home economics studies.

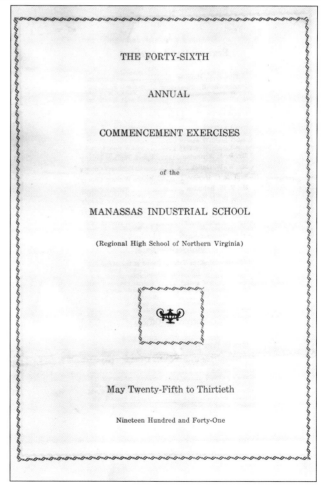

THE FORTY-SIXTH

ANNUAL

COMMENCEMENT EXERCISES

of the

MANASSAS INDUSTRIAL SCHOOL

(Regional High School of Northern Virginia)

May Twenty-Fifth to Thirtieth

Nineteen Hundred and Forty-One

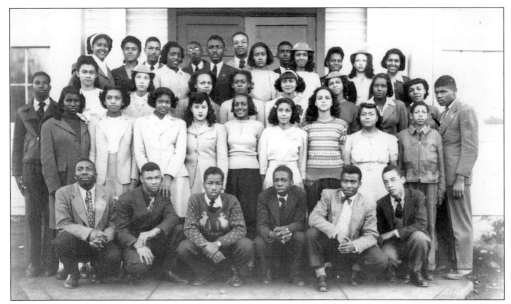

The Rosenwald High School 1946–1947 graduation class is, from left to right, (first row) Asbury Sanker, Howard Sharp, Leon Craig, Willie Combs, Wallace Lacy, and Aubrey Smoot; (second row) Lucille Settles, Lillian Moore, Grace Moore, Micky Jenkins, Dorothy Brown, Phoebe Nash, Shirley Robinson, Mary McLain, Alley Green, and William Latney; (third row) Peter Moore, Dorothy Beale, Rosena Rowe, Lillian Smoot, Clarissa Tyler, Constance Tapscott, Audrey Thompson, Constance Bland, and Rachael Smoot; (fourth row) Verna Walker, Mae Smith, Charles Anderson, Doris Bland, Clifford Hazzard, Charles Taylor, James Davis, Lettie Carter, Jerry Jeffries, Delores Sharp, Louise Marshall, Alice Addison, and Catherine Brown.

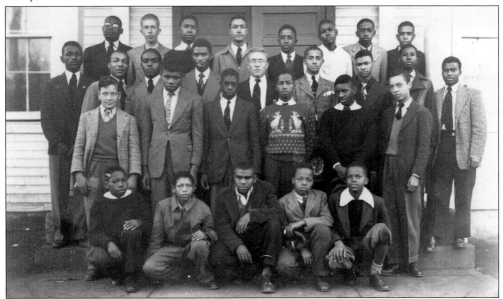

New Farmers of America was an organization for African American youth studying agriculture in schools in the eastern and southern United States. The NFA was formed in 1927 and ended in 1965, when it became part of the desegregated Future Farmers of America. This photograph was taken at Rosenwald High School between 1946 and 1947.

William H. Lewis Sr. was a native of Holland, Virginia. A 1936 honor graduate of Virginia State College, he also studied at Virginia Polytechnic and Cornell Universities. Lewis taught at Fauquier's Rosenwald and W. C. Taylor High Schools. In 41 years as an educator, he was absent once: after attending his brother's funeral in Philadelphia, he drove his eldest daughter to her freshman year at Virginia State. Lewis's wife, the former Clara Washington, a Fauquier native, was also an alumna of Virginia State. She began teaching in a one-room school in Orlean and taught for more than 40 years. There have been five generations of Fauquier teachers in Clara's family: her grandfather, Grant Tyler; her mother, Julia Blackwell Tyler Washington; her son, William H. Lewis Jr.; and her grandson, Charles Wesley Lewis, who currently teaches history in the county.

Eva Blackwell Campbell was born to Clarence and Edith Fields Blackwell on November 30, 1910. Eva attended Blackwelltown School and later Virginia State College's summer school program. She worked as a substitute teacher at the Rosenwald school in Warrenton during the 1940s. In later years, Eva worked as a seamstress in Washington, D.C., and in Warrenton. She married Scott W. Campbell Sr., also known as Hammy (pictured below). They had one son, Scott Campbell Jr. Scott Sr. was born on November 20, 1906, to Hamilton and Mary Smith Campbell. He worked with horses in his early years and participated in black horse shows throughout the Northern Virginia area. Family members recall Scott winning quite a few trophies.

— PROGRAM —

1. Processional
2. Star Spangled Banner — Audience
3. Scripture — Alice Virginia Brown — Ensor Shop
4. Invocation — Rev. —
5. Music — Father Breathe An Evening Blessing — Graduates
6. Welcome — Robert Osborne Blue — Blackwelltown
7. Ulysses (Monologue) — Theodore Edward Lomax — Murrays
8. Music — Santa Lucia — Greenville Girls
9. A New Day — Audrey Louise Jones — Calverton
10. Music — Softly Now The Light of Day — Graduates
11. The Land Where Hate Should Die — Addie Roberta Webster, Catlett
12. Farewell — Clyde Oddis Gordon — Bristerburg
13. Music — Now The Day Is Over — Graduates
14. Announcements
15. Introduction of Speaker
16. Address to Graduates — Mr. A. G. Richardson, Assistant State Supervisor of Negro Education
17. Presentation of Diplomas — Supt. C. M. Bradley, Fauquier County
18. America — Graduates
19. Recessional — Kipling

GRADUATES

BLACKWELLTOWN
Robert Osborne Blue Rita Virginia Jenkins
Rosie Vernice Lewis Randall Martin
Francis Annabelle Webster

BRISTERBURG
Ewdard Clyde Brown Mable Virginia Brown
James Charles Bumbry Carrie Mae Gibson
Clyde Oddis Gordon

CALVERTON
David Junior Blackwell Oscar Redd
Audrey Louise Jones

CATLETT
Joseph James Addison Addie Roberta Webster
Sarah Irene Williams

ENSOR SHOP
Alice Virginia Brown

GREENVILLE
Naomi Louise Nickens Doris Ann Turner
Robert Ellsworth Turner

MURRAYS
Clarissa Elizabeth Chapman Vivian Irene Webster
Theodore Edward Lomax Rollie Green Wilson Lomax

On June 2, 1942, at the Blackwelltown School in Midland, the Cedar Run and Lee School Districts held their graduation exercises. The graduates were from the communities of Blackwelltown, Bristersburg, Calverton, Catlett, Ensor, Greenville, and Murrays. A. G. Richardson, assistant state supervisor of Negro Education, gave the address to the graduates.

Foster Hills' two-room school in The Plains served students in grades one through seven. The PTA was instrumental in raising funds to supply additional classroom items. Students were strong in academics but also enjoyed seasonal and holiday projects and looked forward to deliveries of milk and Tru-Ade from the local dairy. The entire community supported students' evening activities at the school, and parents substituted whenever a teacher was absent.

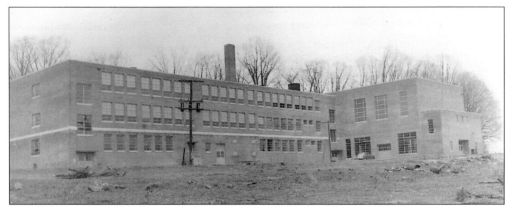

Until 1964, most African American children attended one- or two-room framed school buildings. Outdoor toilet facilities, one for each gender, were used. Water was obtained from local springs, but sometimes hand pumps were located outside. Heat was provided by coal or wood stoves. Parents and concerned community members maintained the lawn and play areas. In 1952, a modern facility was erected in Warrenton. It was named for William C. Taylor, principal of the Warrenton Rosenwald Training School from 1929 to 1945. During evening hours, musical concerts and other affairs were held in the schools. The funds raised were used to improve the condition of the school and purchase educational material for the students. Below, from left to right, John Williams, an unidentified gentleman, Clara Thompson, Grace Murray, John Murray, and Grace Murray (the mother of Grace and John) are standing outside of Taylor High School after attending a musical program.

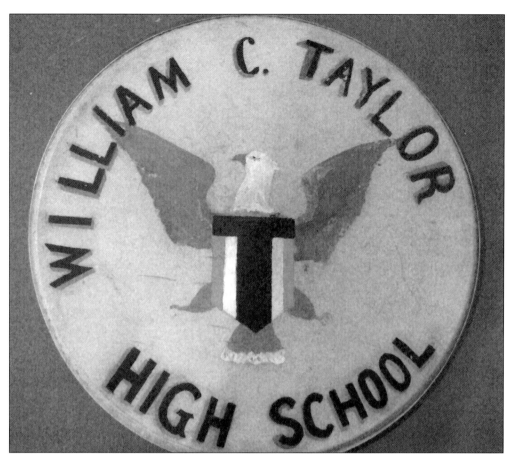

William C. Taylor High School offered instrumental music classes under the direction of Addison E. Lightfoot, a graduate of Virginia State College. The marching and concert bands participated in numerous events, including school assemblies and annual parades throughout the Northern Virginia area. In 1963, Brenda (Be Be) Johnson, a daughter of Robert Johnson and the former Ann Mason of the Bethel community, was a Taylor majorette. As a senior in 1964, Brenda was an extremely active student. She was assistant secretary of the senior class, assistant treasurer of New Homemakers of America, assistant secretary of the school choir, assistant secretary of Future Business Leaders of America, and a member of Just Us Girls sorority and of the Junior League.

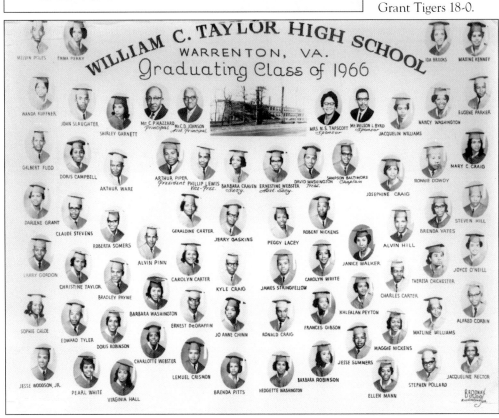

Listed are the Taylor Eagles who played in the Sixth Annual Legion Bowl Game in 1964. The bowl was sponsored by the Lt. Charles Anderson Post 360 of the American Legion. The Taylor Eagles were victorious in 1959, 1960, and 1963. They were defeated in 1961 by Douglass High School and in 1962 by Walker Grant High School. In 1964, the Eagles lost to the Walker-Grant Tigers 18-0.

The students in this photograph are 1966 graduates of William C. Taylor High School. Also pictured are principal Clifford Hazzard (bachelor of arts at Morgan State College and master of arts at Columbia University) and assistant principal Clarence Johnson (bachelor of arts at Howard University and master of arts at Columbia University). N. Sue Tapscott, a class sponsor, held a bachelor of science from Virginia State College, and the other sponsor, Wilson L. Byrd, held a bachelor of arts from Virginia Union University.

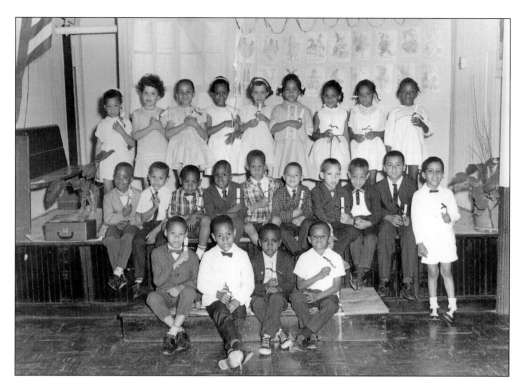

The children pictured here and on the cover of the book were kindergarten students at Green's Private School, which was located on Curtis Street in Warrenton. From left to right are (first row) Earl Carter, Michael Smoot, Anthony White, and Steven Franklin; (second row) Clarence Curtis, Samuel Ball, Gerald Russell, Richard Carter, Mark Jones, William Carter, Allen Chichester, Norman Chichester, Michael Chichester, and Glenwood Jones Jr.; (third row) Evelyn Marshall, Allison Lightfoot, Norma Campbell, Marie Smith, Donna Colvin, Harolyn Berry, Lydia Sharp, Jacquelyn Jones, and Lisa Butler.

John Thompson Jr., son of John and Clara Thompson Sr., played basketball for the Fauquier High School Falcons. John graduated in 1969 and enrolled at Virginia State University. In 1973, he graduated with a degree in health and physical education. Currently he teaches and coaches basketball at Taylor Middle School in Warrenton, in the same building that used to be the segregated Taylor High School Thompson once attended.

Class of Mrs. Joan Williams & Mrs. Polly Jefferies

James Byrd	Michael Lillard
Mary Ann Furr	April McLean
Anthony Garnett	Arthur Robinson
Torronda Gibson	Terrance Robinson
Melvin Grayson	Cynthia Scott
Linda Haines	James Thomas
Andrew Lewis	Jerry Wells
Kimberly Yates	

Class of Mrs. Alice Jackson & Mrs. Doris Hensley

Robin Cooper	George Lewis
Richard Corum	Shelia Lillard
Reana Dodson	Paula Randall
Angelia Franklin	Mary E. Smith
Robin Gaines	Russell Stanley
Earl Jackson	Darrel Tackett
Jeffrey Jenkins	Eric Tapscott
Leslie Lacy	Robert Williamson

Class of Mrs. Jane Hoff & Mrs. Theresa Bolden

Ralph Bland	Antnony "Tony" Lambert
Rodney Carter	Darine Payne
Gregory Edwards	Linda Sams
Darlene Fewell	John Settles
Richard "Eddy" Gibson	Paris Smith
Frank Johnson	Shirley Welch
Teresa Johnson	John Williams

* * * * * * * * * * *

PROGRAMME

OPENING -

 PRAYER
 PLEDGE OF ALLEGIANCE - LEAD BY HEAD STARTERS
 AMERICA - LEAD BY HEAD STARTERS

"TEN LITTLE BUNNIES"---Class of Mrs. Jane Hoff
 and Mrs. Theresa Bolden

"SPRINGTIME IS COMING"-Class of Mrs. Doris Hensley
 and Mrs. Alice Jackson

"SIX LITTLE DUCKS" ----Class of Mrs. Joan Williams
 and Mrs. Polly Jefferies

REMARKS -------Mrs. Carolyn M. Harry, Director

"WHAT'S YOUR NAME" - Bradley Center Head Starters

"WHO STOLE THE COOKIE FROM THE COOKIE JAR" -
 Central Center Head Starters

"THE NUMBER MARCH" - Central Center Head Starters

PRESENTATION OF CERTIFICATES -
 Mrs. Carolyn M. Harry, Director

SING ALONG - Audience Participating
 See your song sheet for the words to the songs

"THIS LITTLE LIGHT OF MINE ------Head Starters

"SO LONG IT'S BEEN GOOD TO KNOW YOU" -
 Head Starters & Audience

REFRESHMENTS

The Head Start graduation was held on May 17, 1973. The goal of Head Start, a federally funded child development program, was to increase the academic, social, and physical abilities of children under the age of five. Its success was dependent upon the participation of the child's family, which the African American community in Fauquier was certainly used to. Teachers included Joan Williams, Polly Jefferies, Alice Jackson, Doris Hensley, Jane Hoff, and Theresa Bolden.

Four
FROM FIELDS TO FRONT LINES

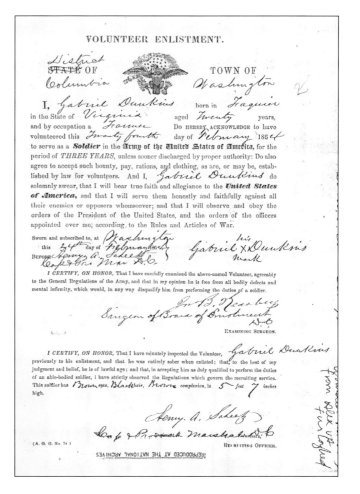

African Americans have always served in the military. During the Revolutionary War, they fought for the British and the United States, both groups promising them freedom. In the Civil War, they fought for the Union, hoping to be free. Some fought for the Confederacy voluntarily, others by force. Gabriel Dankins, emancipated by Dolly Farrow in 1845, joined the Union army in 1864. He received disability payments for his injuries.

Eli Washington was born a slave of Elizabeth Blackwell in 1840 and was one of the slaves emancipated in her 1859 will. He was the son of Elijah and Lucy Chapman Washington. He was drafted into the Confederate army, sent to Dumfries, Virginia, and worked as a teamster, driving a six-mule team. Eli served in Virginia until the later part of the war, when he was transferred to Alabama, remaining there until General Lee's surrender. The witness to his military pension application was William Cowne, whose wife's family (the Botelers) had enslaved members of Eli's family. His pension was approved, and he received two payments of $35. His wife, Amanda, born in 1847, was a daughter of Natus and Sina Washington. The couple lived in the Midland community, where they raised their 10 children. They belonged to Ebenezer Baptist Church.

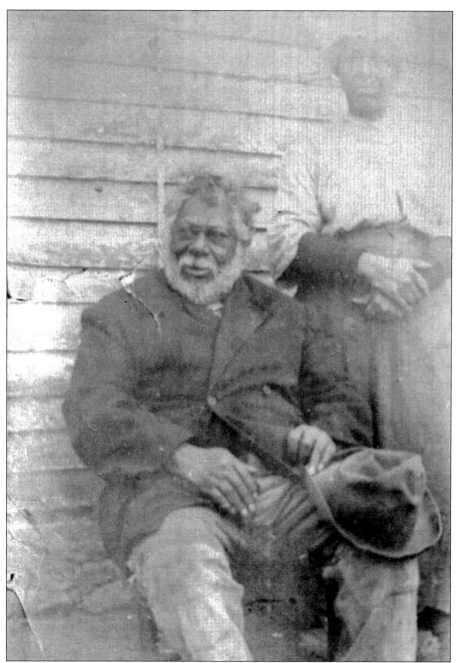

Wesley Washington, who is not related to Eli, is pictured with his second wife, Mary. He was previously married to the former Harriet Haley, and they were the parents of eight children. Washington, who was born in 1843, traveled to Washington, D.C., to enlist in the Union army on June 8, 1863. He enlisted for a term of three years and served with the U.S. Colored Troops. For his work as a cook, Washington received a salary of $7 per month. Washington was wounded in October 1864 and was mustered out in September 1865 at Roanoke Island, North Carolina. He lived in Opal, where he owned his farm. The Washingtons belonged to St. James Baptist Church in Bealeton.

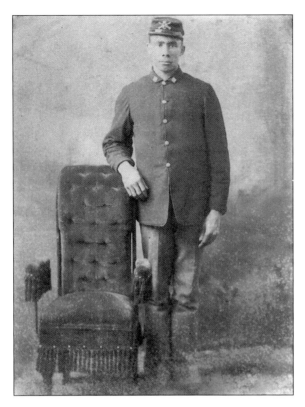

James Dade was born free in Virginia in 1822. According to the Dade family's oral tradition, he was descended from a Native American woman and an Irish man named Daniel Dade. James married a woman named Jane, and they were the parents of eight children. He served during the Civil War and remained in the army for a time after the war ended. Pictured also is one of his grandsons, James William Dade, the son of James Daniel and Sarah Payne Dade. James William was born in 1896 and served in the army during World War I. He died in 1949 and is buried in Arlington National Cemetery.

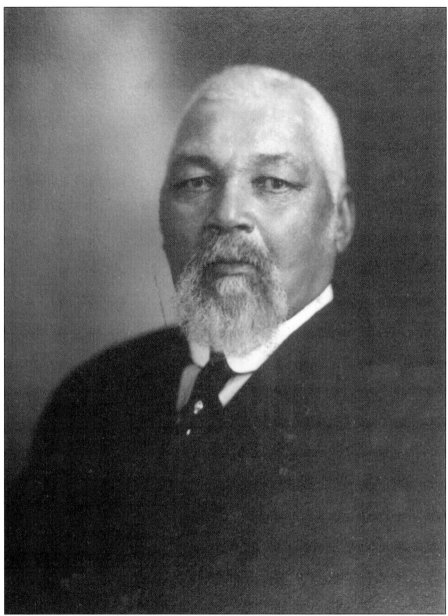

Anthony Dangerfield was born in 1838 on a plantation called Huntley, which was owned by the Skinker family. His mother was Millie Dangerfield; she later married Jerry Burns. Anthony was taught a trade of blacksmithing by his slave owner and followed this trade until he died in 1924. His slave owner, James Skinker, sent him into Confederate service as a body servant to his son William Skinker. William served in the Black Horse Cavalry, and Dangerfield's duties included maintenance of the horses, mules, and wagons for the Confederate army. At the end of the war, Dangerfield was discharged at Staunton, Virginia. He was widowed three times and married four times—to Virginia Mary Jones, Jane Moore, Annie Jones, and Hattie Moore Ray. With Virginia he had one daughter, with Jane he had seven children, and with Annie he had one son. Dangerfield taught all of his sons to be blacksmiths. He sold a portion of his land to the Marshall School District so a school could be built for the African American children of Hume.

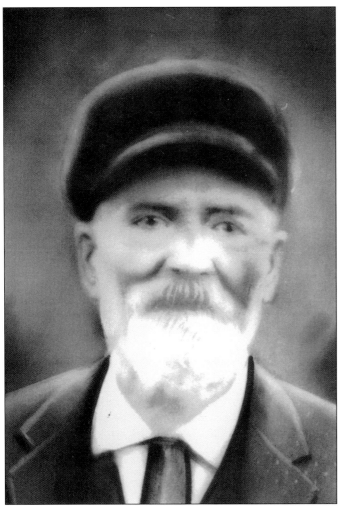

James Dawson (1830–1925), the son of Caroline Dawson, married Evaline Weaver around 1860. Two years after her death in 1876, he married Lydia Tyler (1840–1914). In 1915, Dawson married Lucinda Pollard. He served as a teamster for the Confederate army and raided the Union army's supplies. Union forces nicknamed him "Yellow Jacket" because like the bee, he was small in stature, his bite was quick, and his retreat was rapid. One of the reasons he was never caught was because he would put his horse's shoes on backwards and those who tracked him were always headed in the wrong direction. Dawson worked with horses for the remainder of his life, earning a county-wide reputation as a great trainer. The horses he trained won ribbons at the Rectortown, Manassas, Warrenton, and Culpeper horse shows. Dawson was a trustee of St. John Baptist Church in Hurleytown.

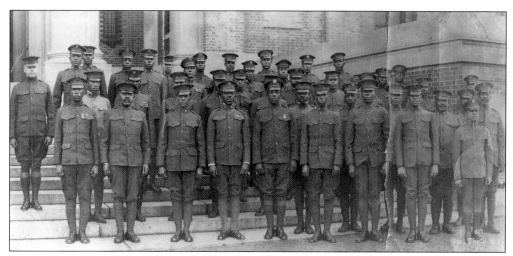

Alexander Daniel Brent was born in October 1879 in Rectortown to James and Frances Page Brent and was named for his maternal grandfather. He enlisted in 1900 in Washington, D.C. Brent served in Cuba, New Mexico, Arizona, and Nebraska. From December 1917 to June 1919, he served in France. He married Lula Scott Tracy in 1920, and he left the armed forces on October 21, 1922, in Washington, D.C.

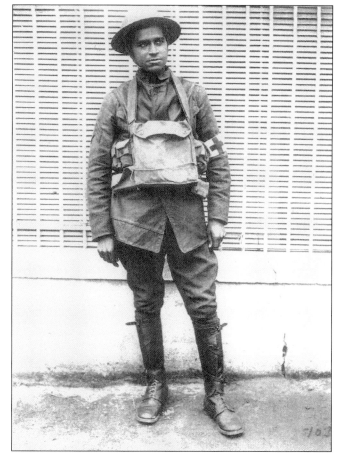

Eugene Thomas Alexander was born in Bealeton in 1894 to Frank and Cordelia Fields Alexander. He married Anna Short in 1919. He attended Howard University for two years and worked for the Bureau of Internal Revenue. He was inducted into the U.S. Army cavalry in 1918 at Warrenton and trained at Camps Lee and Stuart. Alexander was promoted to sergeant and served in Brest, France. He was discharged on July 11, 1919, and died in 1944.

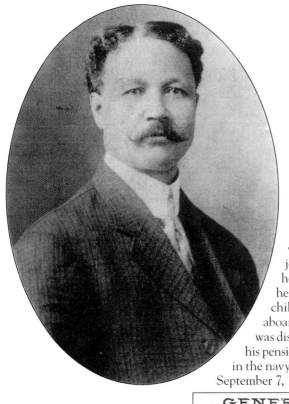

Abner Walker Dangerfield was born in 1841 to Millie Dangerfield, a slave of the Skinker family. Abner was not a strong child, so he was taught to read and write by his slave owner and given the job of bookkeeper. After the Civil War, he attended Howard University. In 1878, he married Jane Solomon, and they had six children. Abner served in the war with Spain aboard the USS *Buffalo* as a cabin steward and was discharged in 1899 in New York. He filed for his pension in 1920. Later he worked as a messenger in the navy yard in Washington, D.C. Abner died on September 7, 1926, in Washington, D.C.

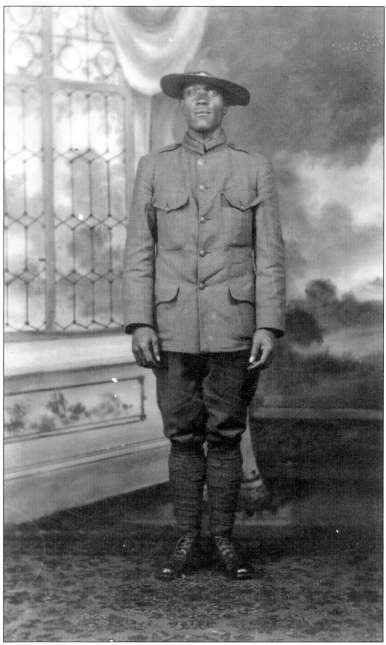

George Washington Barber II was born in Hume on November 23, 1891, and was the eighth child of John Henry and Elizabeth Dowe Barber. He was named for his paternal grandfather. He enlisted in the Ohio National Guard on October 28, 1917, in Youngstown, Ohio. Following is a list of his assignments: 158th Depot Brigade until February 28, 1918; Company L, 365th Infantry until June 9, 1918; 152th Depot Brigade until October 6, 1918; 20th Orders Supply, Company C in Anatol, New Jersey, until December 21, 1918; and 153th Depot Brigade until his honorable discharge as a private on January 10, 1919. He was discharged with a five-percent disability. This is a photograph that Barber sent to his brother, John Henry Barber Jr., who lived in Pennsylvania. Barber married and lived the remainder of his life in Youngstown, Ohio, at 416 Gardner Street.

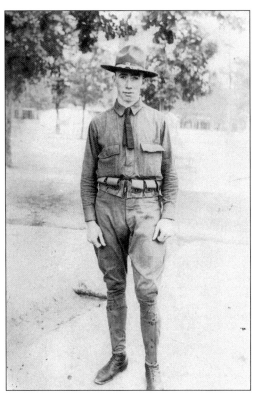

Eugene Dade was born in the community of Dudie on January 2, 1893, to John Daniel and Sarah Payne Dade. The Dade family has a long history of military service. Eugene was in the U.S. Army and served in World War I. John Scott Dade (below), commonly known as Scott, was born in 1894 and was the brother of Eugene. He married Martha Smoot on July 29, 1916, and they had a daughter named Virginia Dade. Scott also served in the U.S. Army in World War I. He received a Gold Star and died in the service of his country.

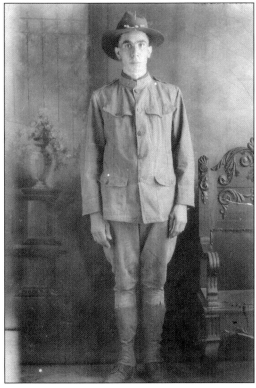

William Henry Brooks Jr. (standing) was born on April 2, 1892, in Orlean to William Henry and Mary Jane Carter Brooks. He attended Orlean Elementary School, where his father taught. He was employed at Bethlehem Steel Company in Baltimore, Maryland. Brooks enlisted on July 16, 1918, at Camp Lee as a private in the 155th Brigade, 45th Company in the Regular Army. He was discharged on December 13, 1918, from Camp Green in North Carolina. He married Ethel Frazier and had one daughter. William Franklin Oliver (below) was born on December 8, 1894, in Midland to William and Betty Whitney Oliver. He was employed as a rigger for Bethlehem Steel. He enlisted at Baltimore, Maryland, on April 29, 1918, as a mess attendant in the Naval Reserves. Brooks was discharged on September 22, 1918, in Hampton Roads, Virginia. He was a member of the Ebenezer Baptist Church and died on March 31, 1982.

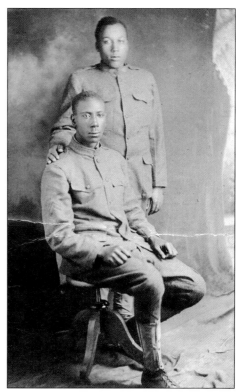

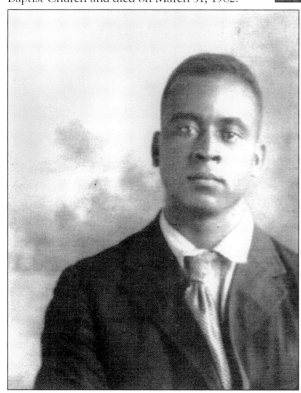

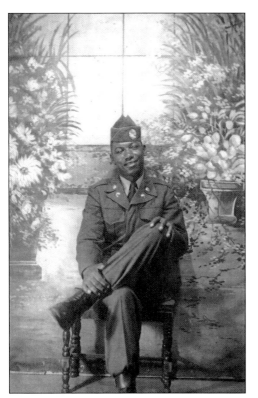

Melvin Leroy Tates was born on March 25, 1927, to Gertrude Lee Tates in a community called Condee. He attended school in Fauquier County, Virginia, and continued his education while serving in the U.S. Army. After being honorably discharged on November 9, 1956, he was employed by the Fauquier County School System until his retirement. Melvin Tates was married to Polly Myers. He died on September 28, 2003, in Amissville, Virginia. In 1925, Edward Tates (below) was born in the community of Orlean. He was a son of Whitfield and Lilly Duvall Tates. During World War II, he served in the U.S. Army, attaining the rank of captain.

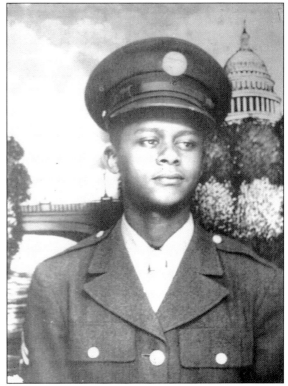

Browning (Brownie) Robinson was born in 1921 in Orlean to Lemon Ernest Robinson Sr. and Bessie Champ Robinson. Browning learned stonemasonry and bricklaying from his father and in this manner supported his family. He married Mary Grigsby and joined Providence Baptist Church. Browning entered the U.S. Navy in 1943 and was honorably discharged in 1946. He died in 1993 and is buried in the Culpeper National Cemetery in Culpeper, Virginia.

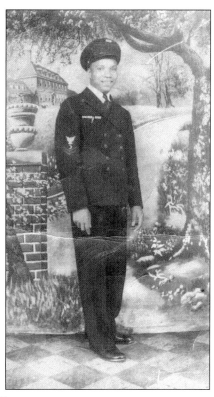

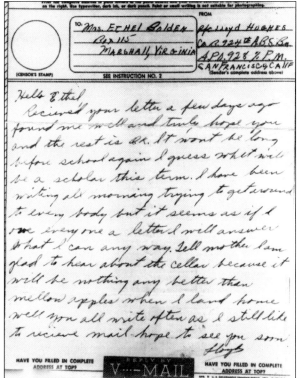

Lloyd Allen Hughes, the son of John H. and Mary Wanser Hughes, was inducted into the army in 1943. He wrote to his sister, Ethel Bolden, eager for news of the Ashville community. The recipient of an Asiatic Pacific Service Medal, Good Conduct Medal, and Victory Medal, Sergeant Hughes was honorably discharged in 1945. With his wife, Catherine Smith, and five children, he belonged to Mount Nebo and served as a deacon.

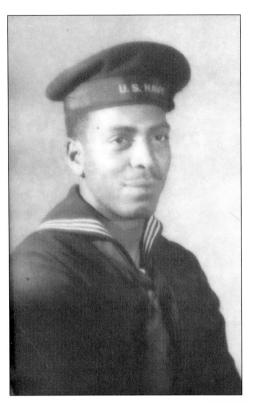

Malachi Grant was born on September 7, 1917, in Rectortown to Robert Alexander and Edmonia Johnson Grant. He married Doris L. Smith, the daughter of Emerson and Wilhelmina Reed Smith. Doris Grant was president of the Fauquier County branch of the NAACP. Malachi served in the U.S. Navy during World War II. Currently he is a member and trustee of Mount Olive Baptist Church in Rectortown.

Selby William Tapscott was born in 1930 to Selby Samuel and Daisy Lofty Tapscott. A corporal with the U.S. Signal Corps during the Korean War, he was on loan to U.S. Army and the U.S. Air Force Strategic Air Command. He married Norma Catherine Chase in 1955.

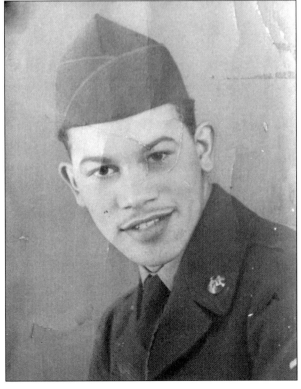

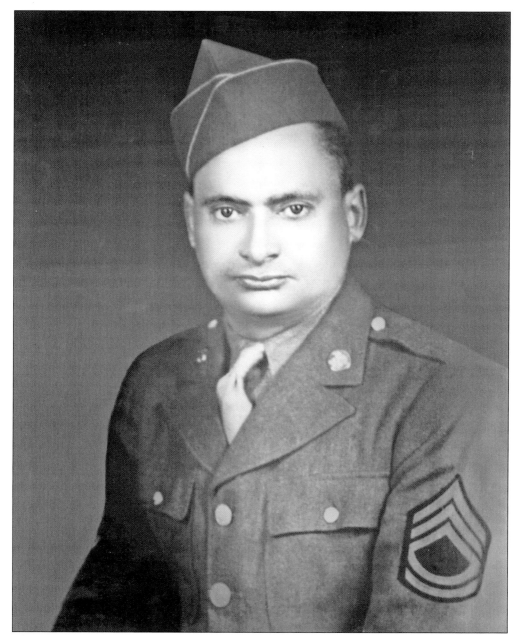

Abner Adams was born in Delaplane to Robert and Mollie Smith Adams in 1901. On May 21, 1944, he sent the following letter, which his family still retains: "My Dear Mother, Have been receiving your mail regularly and am always glad to know that you and Father and the rest of the family are alright. I am well and doing my (illegible) to shorten the war so I can get back to the States. Received letters from Edith and Minnie but have not had time to answer. You and Father take good care of yourself and don't worry about me. Your son, Abner." Abner Adams died June 1, 1944.

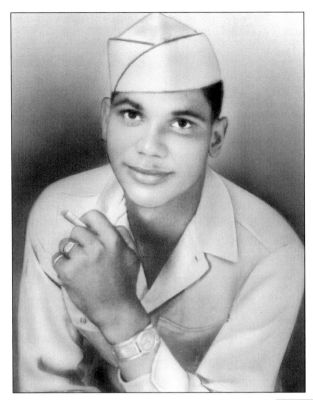

John Anthony Dangerfield was born in the community of Linden to John Thomas and Effie Pearl Hackley Dangerfield on July 24, 1927. He received his education in the Fauquier County School System and served in the U.S. Army. Dangerfield married Pearl Mitchell and moved to Front Royal in Warren County, where he still lives today.

James Brown, born in 1922, was the son of Elmo W. and Anna P. Blackwell Brown. This grandson of Eli Addison and Emily Mauzy Blackwell served in the U.S. Army during World War II. As a youth, he attended Rosenwald High School in Warrenton. He lived in the community of Remington and married Delores Owens.

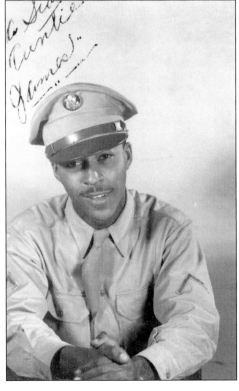

Harry Brown was born in 1929 to Percy and Nannie George Brown. He attended school in Morgantown, where he was raised. A member of Mount Nebo Baptist Church, he sang with the choir. During the Korean War, Harry served in the army. After his discharge, he relocated to Arlington to find work but continued to care for his mother and stepfather, Sandy Tates, until their deaths.

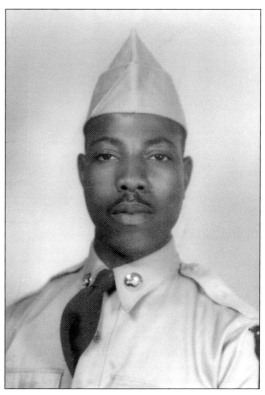

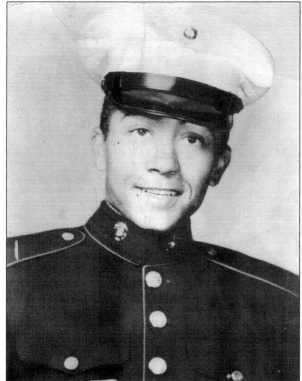

Robert Chichester was born in Warrenton in 1933 to Herbert and Eleanor Barber Chichester. He married Erie Flake and had two children. Robert was a marine, serving in Korea from 1953 to 1957. For two years after his discharge, he worked for the National Library of Medicine, but he resigned to attend Virginia State College. He later served in the army from late 1970s until 1998, and he retired from the Department of Defense.

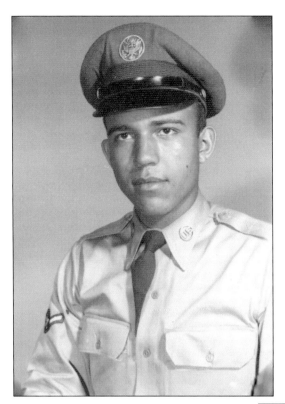

Scott Wood Campbell Jr. of Frytown was born to Scott W. Campbell Sr. and the former Eva Blackwell. Scott was in the U.S. Air Force from 1954 to 1957 and worked as an airplane mechanic. He was later employed by Melpar and Vint Hill Farm Station. His first wife was Margaret Elizabeth Lambert, and from this union there were four children. Later he married Dora Blackwell.

Raymond Lambert was born to Samuel Bailey and Polly Lambert of Turnbull. He worked with horses in California before being drafted into the U.S. Army during the Vietnam War. He held the rank of private first class and was wounded in action when his platoon was ambushed. He spent a year recovering in a Tokyo hospital. Lambert was medically discharged and returned to his work as a groomsman.

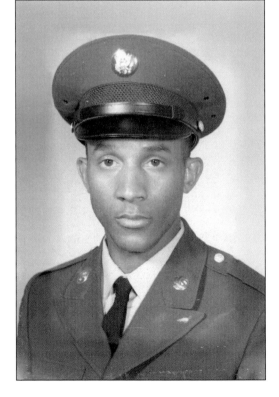

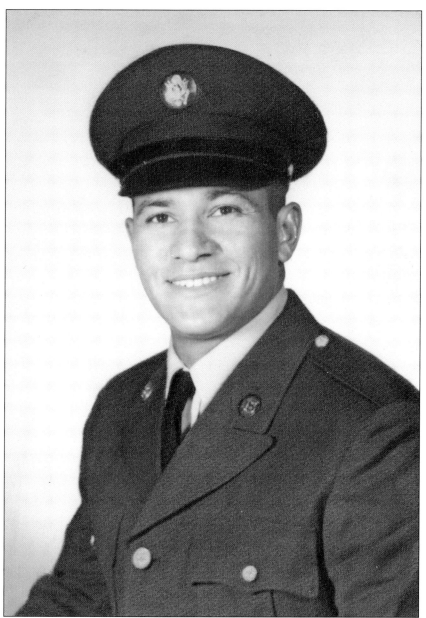

Eugene Ferguson was born in Culpeper County on July 24, 1937, to Hugh Maxwell and Philippine Anderson Ferguson, who was from Crest Hill. Ferguson graduated from Carver Regional High School in Rapidan, Virginia, in 1954, after which he worked in construction and farming. He married Nannie Carter on April 20, 1957, and they were the parents of two daughters. Ferguson was drafted and served in the 101st Airborne Division and the 265th Chemical Company from 1961 until 1963. In 1963, when James Meredith sought entrance as the first African American student at the University of Mississippi, the segregationist governor, Wallace Burnett, blocked the doorway. It was Ferguson and his company who physically removed the governor so that Meredith could enter. After being discharged, Eugene worked for Eastern Airlines for 26 years, then Eastern Airline Shuttle, Trump Shuttle, and finally U.S. Air Shuttle. He retired in 2000 and lives in Hume.

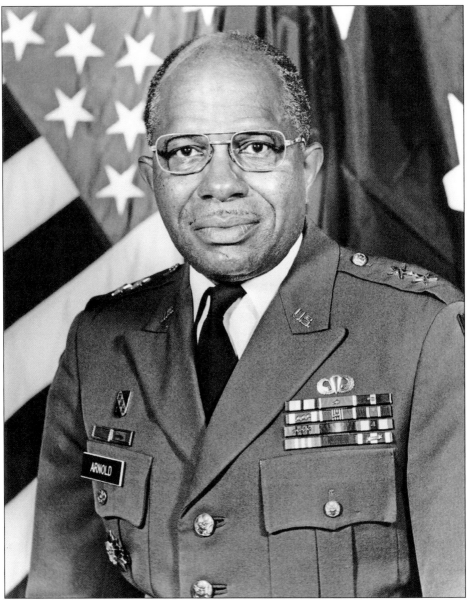

Maj. Gen. Wallace C. Arnold, a sixth-generation Fauquier native, is the son of Winslow and Lydia Gibson Arnold and a grandson of Milton and Lillie White Arnold and William and Catherine Gibson of the Cross Road community. He served as commander of the National ROTC and retired after 30 years of service. He holds a bachelor's degree from Hampton Institute and a master's degree in personnel management and administration from George Washington University. A graduate of the Naval War College, he has done additional study at the University of Michigan and Harvard University. After retirement, he served at Hampton as director of the Technical Data Management Laboratory. Subsequently, as interim president of Pennsylvania's Cheyney State University, he was instrumental in leading that institution to the restoration of its accreditation. Arnold's awards include the Distinguished Service Medal, Defense Superior Service Medal, Legion of Merit, and Bronze Star. He and his wife, the former Earlene Costner, are the parents of two daughters and have one grandson.

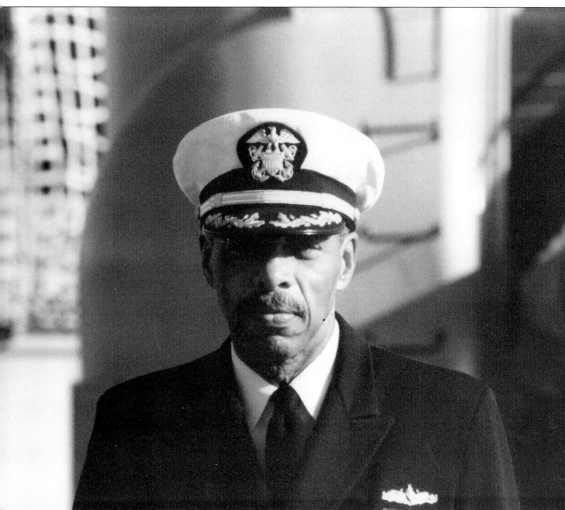

Lt. Comdr. Welford C. Robinson (1927–1994) is a grandson of Edward and Henrietta Fox Robinson and the son of Welford and Erma Alston Robinson of Remington. He joined the navy at 17 after graduating from Baltimore's Dunbar High School. After 12 years in the military, he earned a bachelor's degree from Morgan State College, a master's degree from Johns Hopkins University, and a doctorate from Rutgers University. Robinson retired as lieutenant commander and became an assistant professor at the University of Baltimore. He was an active member of the Veterans of Foreign Wars and several naval officers' associations. He is survived by his wife, the former Jeanne Locks, and a daughter, Daphne Whittington.

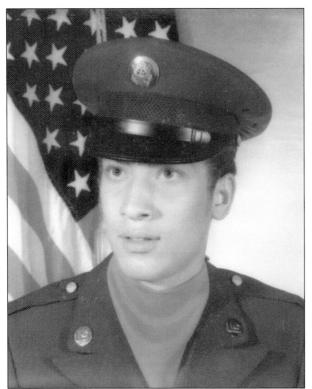

Winsten A. Reed was born in 1953 to Eugene and Violet Anderson Reed. He graduated from Fauquier High School in 1972 and served in the army from 1973 to 1993. Reed retired as a sergeant first class in the U.S. Army Recruiting Command. He married Otha Jean Osborn, and they have two children. Winsten's sister, Linda Reed Jolley, graduated from Fauquier High School in 1971. From 1974 to 1981, she served in the U.S. Army, where she rose from private to staff sergeant. Linda attended the University of Texas Nursing School, earning a nursing degree in 1984. She worked at Madigan Army Medical Center in Tacoma, Washington, from 1985 until 1986. She was commissioned a second lieutenant in the U.S. Army Nurse Corps. She retired as lieutenant colonel in June 2006. She and David Jolley have two children.

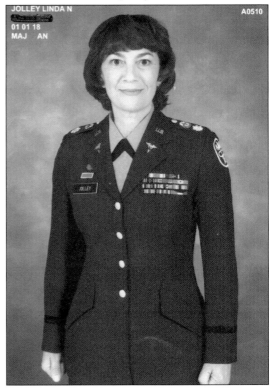

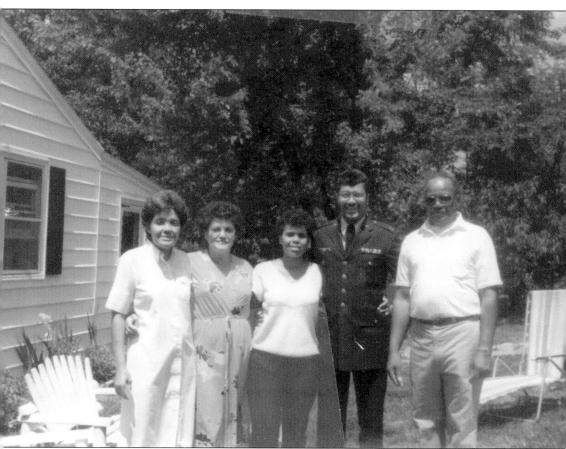

Robert Adrian Upshur was born in the community of Marshall, on the outskirts of Rectortown. He was a son of Robert A. Upshur Sr. and his wife, the former Pauline Hall. His formative years were spent attending the Mount Olive Baptist Church in Rectortown. He married Pamela Boyd, and they had three daughters. Upshur was a 1976 graduate of Fauquier County High School. He received a full, four-year scholarship to attend the U.S. Air Force Academy in Colorado Springs, Colorado, one of the most selective colleges in the United States. Upshur's admission is certainly a testament to his ability and determination as well as being indicative of the quality of education afforded Fauquier County students. Upshur served for 21 years in the U.S. Air Force, from May 1980 to September 2001. He attained the rank of lieutenant colonel.

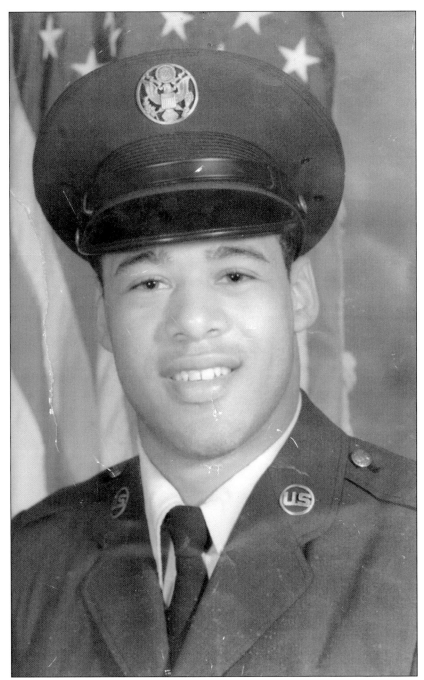

Earl Carter is a son of Dorothy and the late John Carter. In 1979, he graduated from Fauquier High School. He entered the Air Force in November 1979 and retired as a chief master sergeant (E-9) in November 2005. (Only one percent of the enlisted force achieves this milestone.) At his retirement, Carter was serving as the 89th Operations Group training superintendent at Andrews Air Force Base in Maryland. He was responsible for more than 450 enlisted fliers who supported the president, vice president, and other dignitaries. Carter is currently employed with the Office of Personnel Management as a background investigator.

Five

TIES THAT BIND

LOOKING AHEAD
BY GEORGE S. BENSON
Agricola

Hurrying along "K" street in Washington a few weeks ago, the cab in which I was riding narrowly escaped an accident. Somebody, absorbed in thought, carelessly stepped off the curb in front of the taxi and the driver veered sharply to the left to avoid striking him. I saw the man. He was tall, dreamy-looking, carried a big package and needed a haircut rather noticeably.

Of course, I wondered who he was: maybe a hopeful inventor going to the Patent Office with some contrivance he believed would win the war, or perhaps some learned bureaucrat pondering weighty figures such as fill the pages of the federal budget. Imagine my emotion at hearing the driver remonstrate, "Wake up, you dumb farmer! Dis ain't no corn field."

Did He Mean It?

The driver meant "lout" but he said "farmer", and set me to wondering how many people in America think these words mean the same thing. Not all of them, certainly. But all too many are not aware that farming is a real art at which louts do not succeed. Not enough people realize that the farm problem ought to be receiving far more intelligent attention than it is getting. One of America's gravest dangers in the present crisis is a low appraisal of the skill required on American farms.

The average farmer in the United States is an alert, thinking individual. Even a good farm hand is amazingly versatile. He is obliged to be, in order to do his work. Farming is a calling of many skills. A farmer does not have to be a veterinary surgeon but he must know how to breed and feed and care for livestock. A farmer need not be a graduate meteorologist but he has to know something about forecasting the weather if he hopes to succeed.

THE CIRCIUT
Published monthly at Catlett, Virginia

VOLUME VI. No 8. MAY. — 1943 PRICE 5 CENTS PER COPY

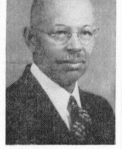

THOMAS C. TYLER

AWARDED MODERN FARMER DEGREE

In connection with their National N. F. A. Day Observance, the Agricultural Students of the Rosenwald High School conferred upon Mr. T. C. Tyler the Modern Farmer Degree to which he was electd at the State Association in Petersburg last June.

This is the highest degree to which a present or prospective

REV. LAVAUGHN V. BOOTH INSTALLED

Pastor of the First Baptist Church, Warrenton, Va.

In a service marked by its deeply solemn simplicity, the Rev. LaVaughn V. Booth was installed pastor of First Baptist Church, Warrenton, Va., the second Sunday afternoon.

Rev. Porter, of the Howard University School of Religion and former room-mate of Rev. Booth, most efficiently presided over the following program: HYMN, the choir and congregation; Scripture reading, Rev. Clayton Tyler; Prayer, Dea. J .W. Stevens; Hymn, Choir; Announcements, Dr. Anderson, Assistant Clerk. Rev. Porter, then in a brief tribute to his Dean presented Dean William S .Nelson, of Howard University, School of Religion, who delivered the Installation Sermon. Installation Prayer, Rev. J. W. Woodson, Minister of Mt. Zion Baptist Church;

LESLIE PINKNEY HILL

Manassas Commencement Speaker.

The Forty-Eighth Annual Commencement exercises of the Manassas Industrial School will be held on Sunday, May 30. This year the exercises will be confined to one day only. The Baccalaureate Sermon will be delivered at 11:30 A.M., by the Rev. W. E. Costner, Pastor of Second Baptist Church, Falls Church.

The Closing exercises will be held at 4 P.M. Dr. Leslie Pinkney Hill, President of Cheney State Teachers College, Cheyney, Pa. will deliver the address. He was Principal of the Manassas Industrial School for five years.

The Class of 1943 will number approximately 50.

and a guide for a modern way of living that will produce happier and fuller life for all who will abide by its precepts. In the course of his sermon he said: "It is the duty of the church to minister to all mankind. The world is too difficult for a divided church." So intent was the congregation up-

Most African American newspapers in Virginia during the early 20th century were weekly publications. The *Circuit*, advertised as "Virginia's Only Colored Paper North of Richmond," began publication in 1940. Founded by Thomas Chapman Tyler and William H. Lewis Sr., it was published monthly until 1954. Staff members included Oscar White, Dr. J. H. Anderson, and Rev. J. C. Hackett. Subscriptions and advertisements from white and African American merchants supported the paper.

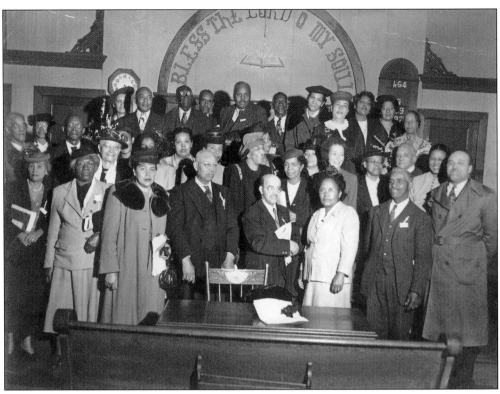

MACARIA FT. 891
U. O. T. R., WILL CELEBRATE ITS
Fifth Anniversary
WITH
THANKSGIVING SERVICES,
Thursday, Nov. 28, 1901.
At SHADE OAK BAPTIST CHURCH
CATSLETTS, VA.

The Fountain will assemble at 10 a. m., Proclamation Service and Devotional Exercises, 10:30 a. m., Address of Welcome by Rev. T. T. Hedgman, at 11:15 a. m., Address of Response by Mr. T. W. Neverdone at 11:30 a. m. Address of Presentation by the Worthy Master at 11:45, Address by the Worthy Chief at 12:15
INTERMISSION at 1:15 P. M.
Annual Sermon by Rev. C. M. Tyler at 2:30.

All neighboring Fountains are invited to send messengers to participate in these exercises and the public generally is asked to accept the cordial welcome which awaits your arrival at this meeting.

Come and see! Come hear and learn! Come and investigate! Come and join! Come and be benefited by making the blessings of the organization yours! Remember that the greatest good consist chiefly in the good we do other. Come!!
Yours in the bonds of U. T. and C.

EDWARD D. HOWE, W. M,
T. T. HEDGMAN, W. Secretary.
C. M. TYLER, W. P. M.

The Negro Organization Society was created by Booker T. Washington in 1912. Its purpose was to encourage collective action among southern African Americans and to solve problems that resulted from racism and discrimination. This 1940 photograph, taken at an NOS workshop at First Baptist Church in Manassas, Virginia, includes many Fauquier residents: Thomas Chapman Tyler, Rev. Joseph Hackett, Sandy Gibson, Lydia Arnold, Esther Williams Tyler, and LuRue Thompson Fox Gaskins.

The Grand Fountain United Order of True Reformers, a fraternal group based in Richmond, Virginia, had an active Fauquier chapter. The group met at area churches, including Mount Nebo Baptist Church in Morgantown. The national organization owned a bank, a newspaper, and retail stores and operated a home for the aged and infirm.

Douglass Ford, the son of Lucy Ford, a free woman of color, was born in 1841 in the area known as the Free State. Douglass was a farmer and purchased 5 acres of land in 1889 in Morgantown, where he and his wife, Ella Timbers, raised their six children. He was a deacon at the Mount Nebo Baptist Church. Douglass died on June 24, 1915.

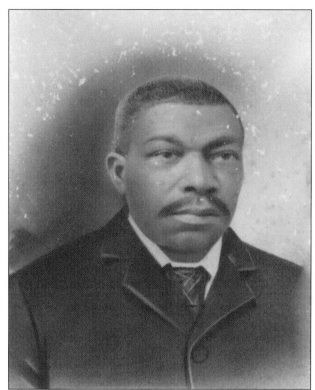

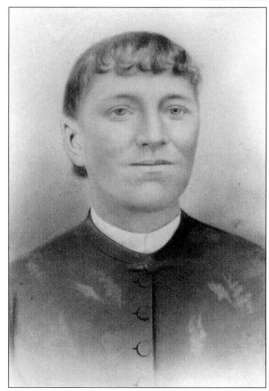

Ella Timbers was born in 1847 to Mildred Timbers. Ella's siblings and mother were enslaved by the Jeffries family. George Jeffries fathered Mildred's children. Ella worked as a midwife and was a member of the Mount Nebo Baptist Church. She enjoyed gardening and had a special love for flowering trees and bushes. She died on May 11, 1920.

Born in 1876, Lillie Grigsby Ford, the daughter of Brister and Nancy Glascock Grigsby, was an entrepreneur. Brister willed land he purchased in 1871 to Lillie. It was a mark of pride for men to have their wives and daughters work at home and not in the fields and kitchens of white people. Although not formally educated, with inherited property, Lillie was able to live off the land, supporting herself independently. In 1892, she married Jesse Ford, a son of Douglass and Ella Timbers Ford. They had three daughters. Jesse worked the farm and Lillie raised chickens, adding tremendously to her family income. These photographs show Lillie, husband Jesse, and daughter Minnie preparing to sell chickens. During later years, she was struck by lightning while trying to move the chickens to safety in a storm and was confined to a wheelchair.

Dora Ella Bradford was born to George and Roberta Ford Bradford in 1883. She was named for her grandmother, Ella Ford. Rev. T. W. Brooke united Dora in marriage to Henry Bushrod, the son of James and Louisa Julius Bushrod, on June 4, 1902. Dora gave birth to at least 10 children, several of whom made Morgantown their home.

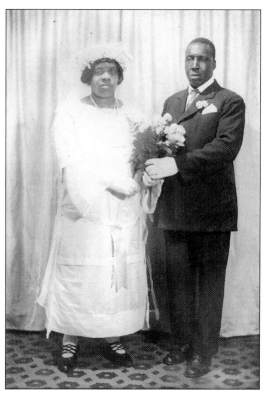

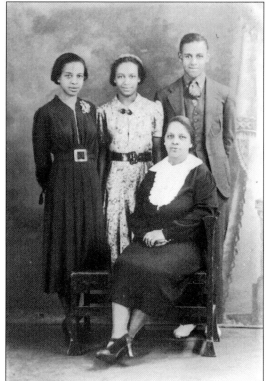

Cassie was one of three daughters born to Jesse and Lillian Grigsby Ford. She married Nathaniel Anderson, who, seeking employment, went north. Once employment was secured at the Viking Hotel in Providence, Rhode Island, Cassie joined him, and there they raised their children, Geneva Grigsby, Nathaniel Leslie, and Menona Ford Anderson. Cassie, pictured with her children, often traveled to Virginia, maintaining a love for family and community.

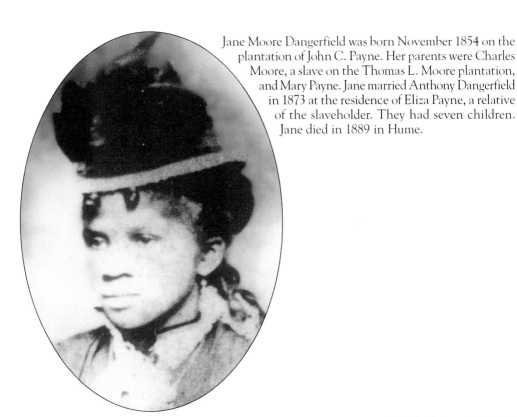

Jane Moore Dangerfield was born November 1854 on the plantation of John C. Payne. Her parents were Charles Moore, a slave on the Thomas L. Moore plantation, and Mary Payne. Jane married Anthony Dangerfield in 1873 at the residence of Eliza Payne, a relative of the slaveholder. They had seven children. Jane died in 1889 in Hume.

Hattie, daughter of Anthony and Jane Moore Dangerfield, was born in 1885. She and John Henry Barber Jr. fell in love. Barber sought permission from her father to marry her but because he could not prove he could provide for her, Dangerfield refused permission. Learning that Pennsylvania steel mills were hiring, Barber relocated in 1910. On January 27, 1911, they married and moved to Pennsylvania, where their descendants still live.

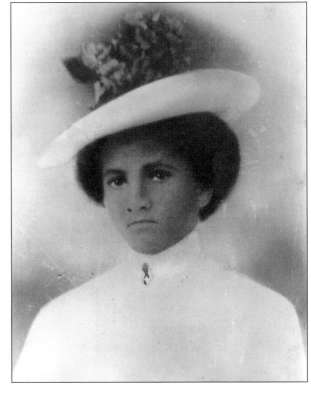

Lloyd Wanser, son of Gillison and Mary Newman Wanser, was married to Nancy Gaskins, and they had a son named James. After Nancy's death, he sought employment as a Pullman Porter. In an era when most African American men were poorly paid farm laborers, Pullman Porters were viewed as having more prestigious and profitable employment. Even though their work required subservience to white people, most of the porters were educated men who, because of discrimination, were limited in their career choices. Another benefit of this employment for Lloyd was that he met his second wife, Carrie Hall. Lloyd opened a store in the Sage community and named it Carrie and Son. The store also served as the local post office.

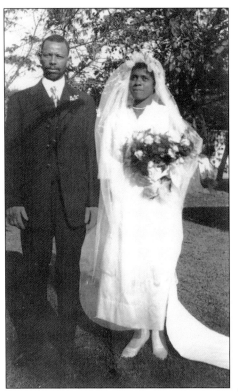

Thomas Chapman Tyler married Esther Williams in 1918. The son of Chapman and Fannie Oliver Tyler and a graduate of Manassas Industrial School, Tyler was a farmer, teacher, and community activist. A member of the Blackwelltown Republican Club, he was county chairman for voter registration efforts in 1940—an important function, as none of the 3,025 black men and women over the age of 21 in Fauquier County were registered voters.

Eva Coles Edwards, daughter of James and Clara Coles, is pictured here with her daughter Elna, who was born in 1913. Elna's father was Sebastian Edwards. She was raised in the Elk Run community, attended Ebenezer Baptist Church, and graduated from Blackwelltown School. In 1931, Elna and Edward Neverdon eloped, moved to Washington, D.C., and raised three children.

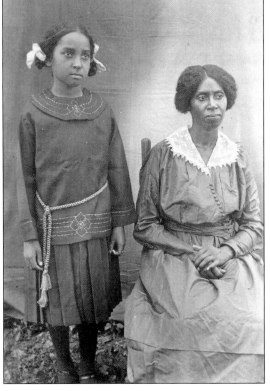

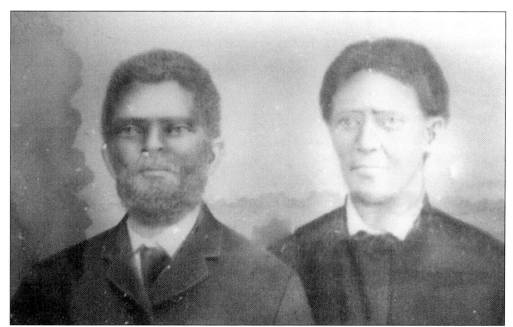

Turner Ferguson Sr. was born in 1830 to Lucy and Martin Ferguson Sr. He married Melvinia (Vina) Taylor, daughter of Henry and Fanny Shores Taylor, who was born in 1834. Both were born in Orlean, where they raised 13 children. Oral history states that the family always referred to her as Melvinia Gaskins, which raises the possibility that she was married to a man named Gaskins before marrying Ferguson.

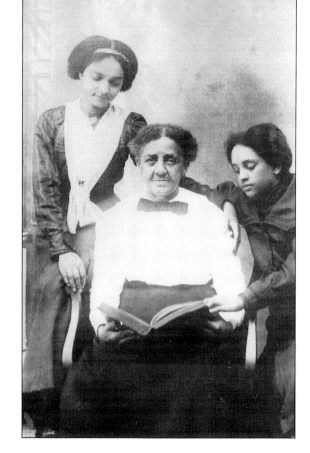

Melvinia, a faithful member of Providence Baptist Church in Orlean, is shown in this photograph with two of her granddaughters, Mary, who is wearing the white collar, and Annie. They were the daughters of Martin Ferguson Sr. and the former Mary Tibbs. Mary married John Hartz, and Annie married Ernest Newsum.

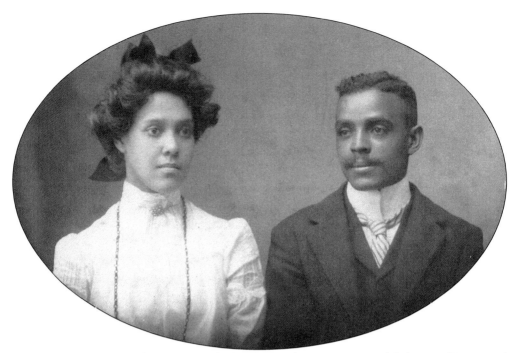

Turner Ferguson Jr. was born on April 25, 1879, in the community of Orlean to Turner and Melvinia Taylor Ferguson. He married Alice Elizabeth Williams, also a native of Orlean, who was a daughter of Charles L. and Edmonia Nelson Williams. Alice was born on September 2, 1885. They married on December 24, 1902, and had nine children.

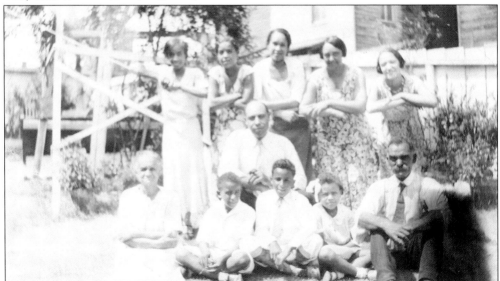

Martin Ferguson, son of Turner and Melvinia, was born in 1864. He married Mary Tibbs, born in 1869 in Madison County, Virginia, to Alfred and Veranda Tibbs. They met, married, and lived in Steelton, Pennsylvania. Pictured are, from left to right, (seated) Mary Tibbs Ferguson, Martin Brooks, Nelson Brooks, Mary Brooks, and Martin Ferguson; (standing) Thelma Bailey, Gladys Ferguson, Annie Newsum, Annie Ferguson Newsum, and Edna Rowe. The man in the middle is unidentified.

Robert Adams was born in 1875 in the Delaplane community to Sidney and Maria Adams. He married Mollie Smith on December 28, 1893, and they had 13 children. In 1876, Mollie was born on the border of Delaplane and Ashville to Mary Smith, a daughter of Elijah and Amanda Smith. Adams and his family attended the First Ashville Baptist Church in Marshall.

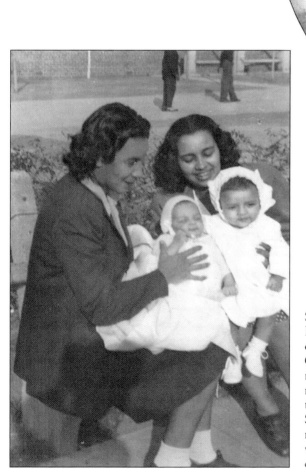

Susie Chloe Nickens (left) and Pauline Chloe Womble, daughters of Thomas and Susie Wanser Chloe, bond in the shared joys of motherhood. Son and daughter, niece and nephew are no doubt the center of this conversation. Susie taught for 36 years and after retirement returned to Greenville, where she now lives. Pauline, the wife of Charles Womble, is deceased.

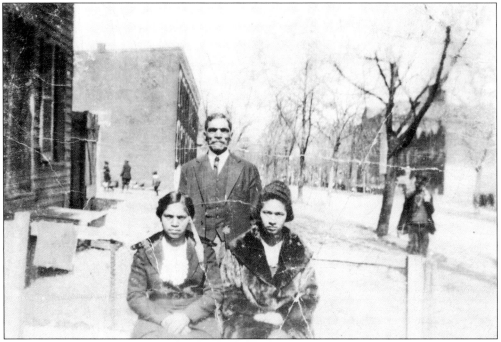

William Williams was born about 1848 to Robert and Sally Williams. Wormley Hughes officiated at Williams's 1880 marriage to Mary Gaines, the daughter of James and Nanny Lee Gaines. Williams worked as a plasterer, a common occupation within the African American community. Their daughter, Lucinda, is pictured with them. She married the widowed Robert Miles and served as church clerk and Sunday school teacher at Mount Nebo in Morgantown. Miss Lou, as she was known within the community, frequently boarded out-of-town teachers in her home. Pictured also is a receipt from Sears and Roebuck, the company that popularized catalog sales and the use of money orders in the late 19th and early 20th centuries. This method of shopping was common in rural areas.

Chauncy DePew Brown and Georgia Lucinda White married on January 18, 1922, in Washington, D.C., and made their home in the Frytown community of Warrenton. Chauncy, a musician, performed throughout the Piedmont area of Virginia and in Washington, D.C. *Life* magazine, the *Washington Post*, and the *Fauquier Democrat* wrote stories about him. He also had the opportunity to play with Duke Ellington. Chauncy was known for playing "Sweet Georgia Brown" in loving admiration of his wife. She was the daughter of Joshua W. and Roberta Clark White. Georgia Brown was educated in the Warrenton public school system and was active in many civic and charitable organizations.

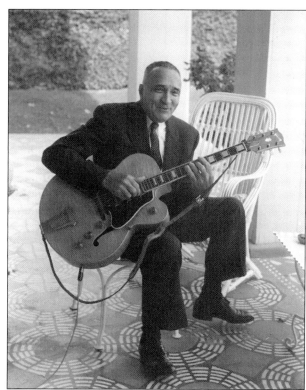

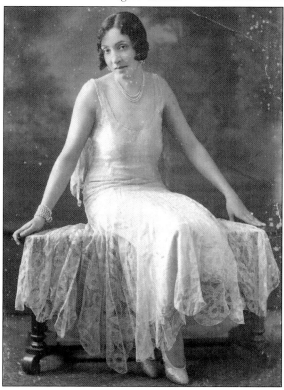

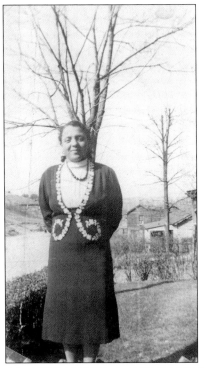

Charles and Mamie Bland started the Black and Gold Restaurant in March 1936. A few years later, Mamie, who was born in Upperville, took over the business, which was located on Second Street in Warrenton. The Black and Gold Inn was a place where people could not only dress up and have a good time, they could enjoy a full-course, delicious meal. The inn even offered rooms for rent above the restaurant, an important feature during the era of segregation, when African Americans were excluded from places of public accommodation. After 40 years of serving the public, Mrs. Bland decided to close, an act that saddened the African American community.

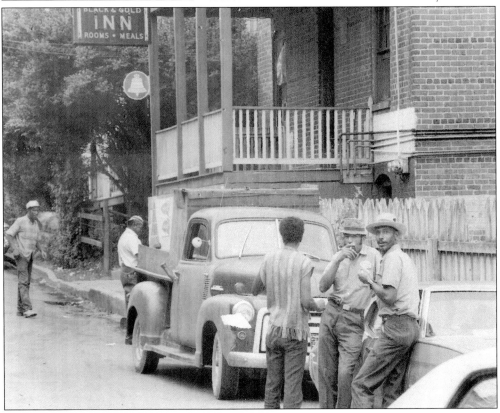

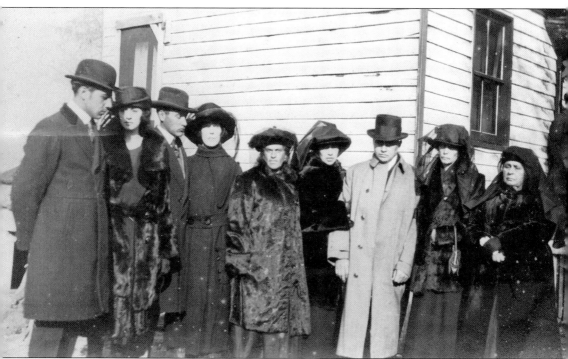

Charles L. Williams Sr. was born on September 15, 1846, in Orlean to John (Jack) Rice, a white man, and Louisa Williams. Jack Rice was the overseer of James Keith Marshall's plantation, and Louisa was a slave who worked in the house. Charles married Edmonia Nelson, the daughter of Easter Nelson and James Edward Dulin (a white man), on November 28, 1872, in Rappahannock County, Virginia. The ceremony was performed by Rev. Cornelius Gaddis. According to the marriage record in the Rappahannock County Courthouse, Charles was 26 years old and Edmonia was 16. They had 10 children. Charles died on November 13, 1922. The photograph shown here was taken on the day of Charles's funeral. From left to right are Jack Rice Williams, Bessie Dangerfield, Rev. Harry Williams, Alice Ferguson, Irie Brown, Mary Walden, Charles Lewis Williams Jr., Nellie Rowe, and Edmonia Williams.

Socializing at the Maryland and Virginia's Milk Producers' Cooperative banquet are, from left to right, Sandy Gibson, Maggie Lewis Tyler, Esther Williams Tyler, Thomas Chapman Tyler, and three unidentified guests. The goal of the integrated group, which began in 1920, was to increase productivity and marketability for Maryland and Virginia dairymen. Tyler's dairy farm, which provided him a comfortable living, also enabled him to offer jobs to other African Americans.

Dr. James H. Anderson was a dentist in Warrenton. He married Jensie Scroggins, the daughter of Herbert B. Scroggins and Mollie O'Banion Scroggins of Morgantown. Doc Anderson, as he was fondly known in the community, was a member of the First Baptist Church of Warrenton and secretary of the *Circuit*. The first Usher Board of the Morgantown Church was organized in 1931 under the leadership of Jensie and her niece Theresa O'Banion.

Robert Chichester's 1960 certificate for brick masonry from Virginia State College and his 1961 training in blueprint reading are testaments to the many generations of African Americans who excelled at these trades. Jacob Cooper made bricks for Waveland, the antebellum home of John Washington, a great-great-nephew of Pres. George Washington. Samuel Bailey's skillful hands did brick and masonry work for the Warrenton Courthouse. Stone fences and structures laid by Robert Gaskins, Alexander Lewis, Aubrey Harris and Sons, the Payne brothers, and others remain throughout Fauquier. Albert Yates deserves credit for currently mentoring Midland area youth through his trade of bricklaying. Fauquier is home to numerous businesses that continue the legacy of skilled work such as Midland Masonry, R and Y Masonry, and GMH Stone Masonry. Many blacks in Fauquier County earned their living as brick masons. Some attended trade schools. Others, like General White Jr., noted throughout Northern Virginia for historic preservation work, were apprentices whose trowels passed from fathers to sons. Throughout Fauquier County and Northern Virginia, the beauty and skill of their work remain.

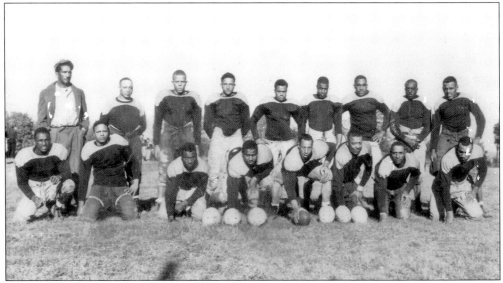

Pictured here is a Warrenton football team. From left to right are (first row) Charles Taylor, Leon Franey, George Brooks, Lut Jefferies, William Walker, Willie Barber, Sug Carter, and William Christian; (second row) Hamilton Chichester, ? Smoot, Arthur Brock, Anthony Chichester, Thomas Russell, Horace Walker, John Thompson Sr., Earl Lee, and Randolph Taylor.

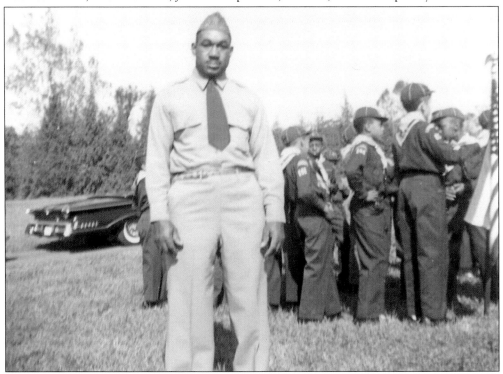

John Thompson Sr., shown here, was one of the leaders of an African American Cub Scout troop that included his sons. Women usually served as den mothers. The troop was preparing to line up along Lee Street for the Warrenton Parade. The Fireman's Carnival usually followed the parade. Albert Campbell was also a troop leader for many years.

Wise Leslie Washington (1883–1970), the son of Wesley and Harriet Haley Washington, married Julia Blackwell Tyler (1880–1960), the daughter of Grant and Clara Blackwell Tyler, in 1908. Julia, a teacher, stopped working when she married. The couple had six children and belonged to St. James Baptist Church in Bealeton. The children worked on the farm, but education was most important. In four years, all six children completed high school. Three became teachers.

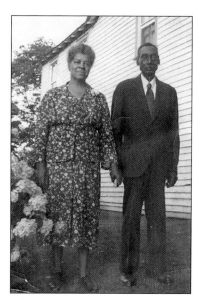

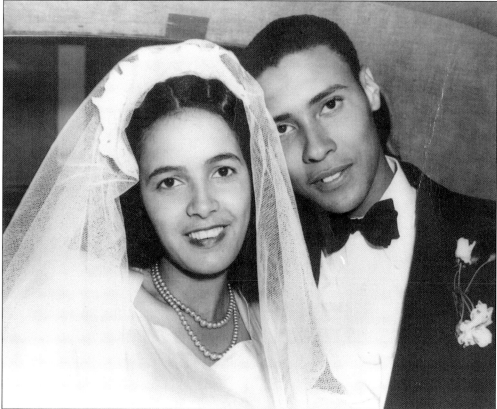

James, the seventh child born to Henry and Mary Wanser Hughes, belonged to Ashville Baptist Church and attended Manassas Industrial School. He enlisted in the army, receiving a World War II Victory Medal prior to being honorably discharged in 1946. James, upon his return, married Dorothy Anderson, and together they had three sons. One son survives and returns often to the community of his parents and grandparents.

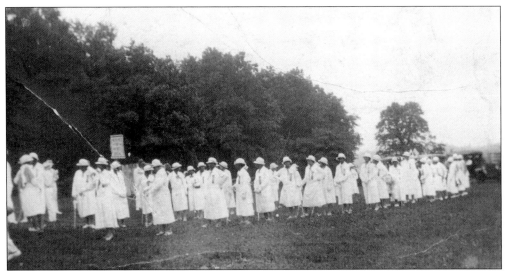

The women participating in the parade are members of the Improved Benevolent Protective Order of Elks of the World, a fraternal group formed in response to their exclusion from the white order of Elks. Long popular in African American communities and rooted in West African cultures, groups such as the Elks fostered charitable outreach, mutual cooperation, and enhanced self esteem for their members.

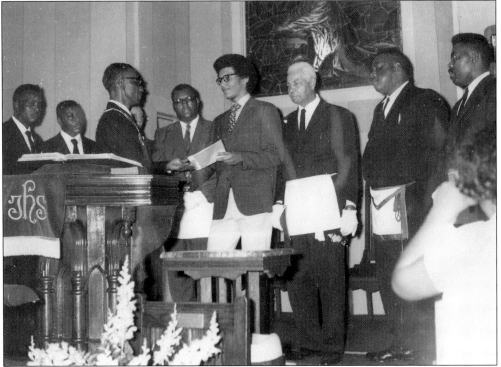

The Midland Lodge 238 of the Masons awards a certificate and scholarship to David Gibson Jr. To Gibson's right is his father, and to his left is his paternal great-uncle, Spurgeon Marshall Tyler. The photograph appears to have been taken at Cross Roads Baptist Church, to which many lodge members belonged.

Memorial Day, a federal holiday formerly known as Decoration Day, is observed on the last Monday of May. It recognizes and pays tribute to American men and women who died while in military service to their country. Many groups and organizations participated in the Memorial Day Parade in Warrenton. Groups would parade down Main Street through Warrenton and end at the Warrenton Carnival grounds. In the first photograph is a color guard troop with the Taylor High School Band in the background. The second photograph depicts a majorette group from Taylor High School and a group of cheerleaders in the background. It is possible that the drum major shown in both photographs is Bernard Smith.

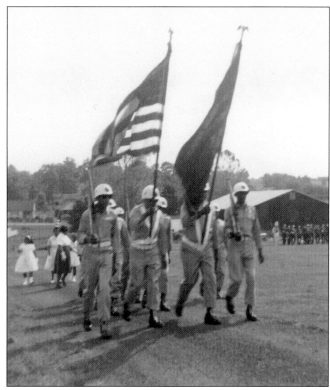

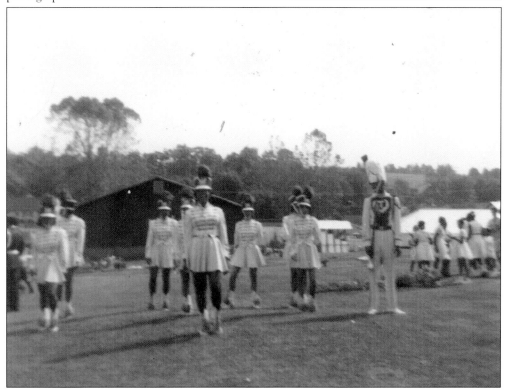

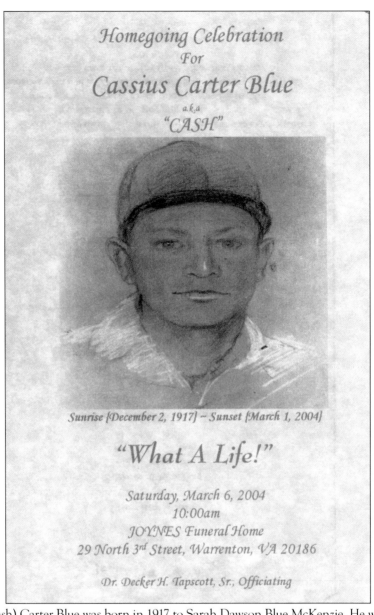

Cassius (Cash) Carter Blue was born in 1917 to Sarah Dawson Blue McKenzie. He was educated in Fauquier County schools and served as a deacon at St. John Baptist Church in Hurleytown. He married Martha Baker, and they had four children. Cash was a professional huntsman for the Casanova Hunt, a fox-hunting club. The huntsman is responsible for directing the hounds during the hunt, and Cash was considered an expert in this field. In a profile published in *Fauquier*, a local magazine, there are interviews with people who attest to his skills and accomplishments. In this same article, Cash attributes his knowledge and success to his mother, "who was a natural-born horsewoman and fox hunter." Cash said, "She broke and trained horses." He credited his grandmother, Carrie Dawson, who was a midwife of Native American ancestry, for his common sense. Staff of the Afro-American Historical Association interviewed Cash on several occasions, and he ended each session by smiling broadly and saying, "What a life." He gave the impression that he enjoyed every aspect of his life. Cash died on March 1, 2004.

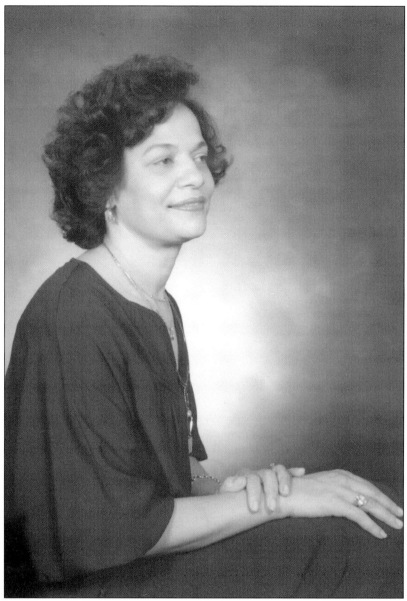

Eva Jenkins Walker was born to the late John Andrew and Eva Tackett Jenkins. She grew up in Opal, attended a one-room schoolhouse at Routts Hill, and graduated from Rosenwald School in Warrenton as valedictorian of her class. She married Robert Walker of Warrenton and had two daughters. After graduating from charm school in Washington, D.C., Eva modeled in several states, including New York at the 1964 World's Fair. She was a talented seamstress and entrepreneur with two beauty salons and a cosmetic line, Eva Walker Cosmetics. Her desire for equal rights for blacks led her to fight for improved education, better communities, and services. She successfully lobbied county officials to provide school bus transportation for the children of the Haiti community. She and her husband, Robert, fought for desegregation in Warrenton. A true visionary, she would gaze through her kitchen window and imagine a safe neighborhood playground. That dream eventually became a reality, and in December 1988, after her untimely death, the Warrenton Town Council voted to establish Eva J. Walker Memorial Park in her honor.

Discover Thousands of Local History Books Featuring Millions of Vintage Images

Arcadia Publishing, the leading local history publisher in the United States, is committed to making history accessible and meaningful through publishing books that celebrate and preserve the heritage of America's people and places.

Find more books like this at
www.arcadiapublishing.com

Search for your hometown history, your old stomping grounds, and even your favorite sports team.

Consistent with our mission to preserve history on a local level, this book was printed in South Carolina on American-made paper and manufactured entirely in the United States. Products carrying the accredited Forest Stewardship Council (FSC) label are printed on 100 percent FSC-certified paper.